Full Frontal T.O.

Exploring Toronto's Architectural Vernacular

Photographs by Patrick Cummins
with text by Shawn Micallef

Coach House Books, Toronto

first edition

 Canada Council Conseil des Arts ONTARIO ARTS COUNCIL Canadä
for the Arts du Canada CONSEIL DES ARTS DE L'ONTARIO

Published with the generous assistance of the Canada Council for
the Arts and the Ontario Arts Council. Coach House Books also
acknowledges the support of the Government of Canada through
the Canada Book Fund.

LIBRARY AND ARCHIVES CANADA CATALOGUING IN PUBLICATION

Cummins, Patrick
 Full frontal T.O. : exploring Toronto's architectural vernacular
/ photography by Patrick Cummins ; with text by Shawn Micallef.

ISBN 978-1-55245-257-8

 1. Toronto (Ont.)--Pictorial works. 2. Toronto (Ont.)--History--
Pictorial works. 3. Toronto (Ont.)--Buildings, structures, etc.--
Pictorial works. I. Micallef, Shawn, 1974- II. Title.

FC3097.37.C86 2012 971.3'541050222 C2012-902270-5

Introduction

By Shawn Micallef

The building at 140 Boulton Avenue is a perfectly Torontonian kind of building. It's the Toronto we know intimately because we walk by this house, and its analogues, all over the city, every day, but rarely pay them any attention; they really aren't very pretty. There 140 Boulton sits, squat, ramshackle and dishevelled – like somebody who's been sleeping in the same clothes for days – on the corner by busy Dundas Street, here little more than a traffic pipe for cars and bikes travelling between the east and west sides of the Don River. Few pay it any mind: it's just one of the thousands of nondescript buildings that make up the wallpaper of our city. Across the street is the Boulton Parkette. It's also the kind of parkette we like to keep here in Toronto: its dishevelledness matches number 140, with bits of trash blowing around, a rusting iron fence, a worn-out lawn and some uneven interlocking brick. We don't do the Tuileries in Toronto; Paris can have that kind of finicky formal park space, our city seems to say, but we don't have time for such frivolity.

Deep down, though, we know we're supposed to like pretty or big things, so when we conjure up 'Toronto' in our mind's eye we probably think of the CN Tower, Casa Loma, the Air Canada Centre or maybe the panorama of downtown skyscrapers as we race along the elevated Gardiner Expressway. We don't think of ragtag 140 Boulton – it would never make it on to a Toronto postcard. But this is the real Toronto. Those clichéed postcard images are at odds, anyway, with how most of us live, on quotidian sidewalks and neighbourhood streets that appear to be better- or worse-off relatives of 140 Boulton. Toronto was never built for glory. As architect Brigitte Shim says, the city was built 'with sticks': on the cheap, quickly and humbly. Because we seem to look elsewhere all the time in Toronto – to a shiny new part of the city, or one of our older gems, or a possible future we might dream of – much of Toronto passes below our radar, even though we're deep in the middle of it every day.

We're missing out, though. 140 Boulton, which you'll see on pages 10 and 11, is full of action and evolution, while the CN Tower has hardly changed at all in thirty-five years. We can't see the first decades of 140 Boulton's life, but we can see how this one structure has, since 1980, morphed and adapted because Patrick Cummins wandered by one day with his camera, stood in front of it, took a picture, and returned over and over to do it again. Back in 1980, 140 was a residential house, or at least it appeared to be one. It had fake brick siding, the kind made out of the same rough material as roof shingles. There was a little front window with the blind drawn, a screen door with a newspaper stuck in the slightly fancy grillwork underneath a metal awning. The narrow strip of dirt between sidewalk and house was fenced in and a little garden appears to be tended to. It's summertime, perhaps early in the season as the foliage seems small, and the shadows are long and from the east. It's morning. Maybe that blind was about to go up and that paper read over a coffee. Toronto daily life carried on, the cars on Dundas went by, and only people like Cummins who pay attention to our in-between spaces and places noticed.

Jump forward a few years to 1988, and 140 has radically changed. Gone is the little garden; it's been replaced by interlocking brick (perhaps to match the parkette across the street). The little door and little window have been made much bigger, and the fake brick siding replaced by vinyl or aluminum siding. The bars on the windows suggest things got a little harder in the neighbourhood: a ladder stored across the front part of the roof and sign reading *Aaron & Greenbelt, General Contractor – Tree Removal – Roofing – Sodding* suggest a rapid transformation from residential to commercial. More time passes and another photo is taken that

finds a sign in Chinese script has been added and the English sign moved from the left to the right side of the building. The door has been made smaller again and the bars have been removed from the window so plants can hang there. This house should have been built with Lego to make it easier for the owners to change their minds. But times are better, perhaps, and business is good. A decade later, in 1998, the wide front door returns and the window is replaced with a garage door. The Chinese sign is gone, but a miniature Chinese gate has been constructed on the roof where the ladder once was. Sod AND soil are now available too. Pictures from 2002 (look, Dundas has a bike lane now!).and 2007 show 140's glory years, when gardens were planted, signs maintained and business concerns continued prosperously. That gate on the roof now frames a bigger sign for Aaron & Greenbelt, and graffiti in the earlier picture has been painted over in the next. The *Sod and Soil* sign is on the ground in one picture, back up in its place the next. The flowers for sale out front suggest this enterprise is trying to cater to gentrifying Leslieville's beautification needs, but the *For Sale* sign in 2007 suggests the end might be near. The final two pictures from 2010 and 2012 show 140 more or less as we know it today (for now, anyway), awaiting another wave of change.

Ugly? Maybe. Boring? Certainly not. Every change to the building is attached to a human narrative, small or large, and while we can only infer what those stories are, there is something here. In gym change rooms, people take off their clothes and their naked bodies tell stories: scars from surgeries suggest horrific accidents, foreign trauma, childhood appendicitis or maybe just a penchant for too much deep-fried food. Our buildings – the civic body – can be read the same way. Change happened at 140 Boulton and across the city, and traces of the past can be seen over time, some fading, some enduring. The ROM may have added a crystal and the AGO a curved glass front, but across the city houses and storefronts have been tweaked and added on to over the years and we've barely noticed. Some of Cummins's photos show additions and alterations to properties that required plans, professionals and some money; others show do-it-yourself repairs and slapdash aesthetics done by people who would get an earful from those judgmental people who host real-estate reality shows on TV.

As it turns out, the cliché is true: the only constant is change. The city is never the same from day to day or decade to decade. Yet most of us don't notice the shifts because they happen in tiny increments on the periphery of our lives. It might be a new tree planted in a yard that grows slowly over the years, or flowers somebody added to the sill overnight. An addition someone puts on their house may go up so slowly we don't notice. Once it's there, it's just there. Skyscrapers go up this way sometimes too: one day there's sky, and there are people's homes up there the next. Storefronts may switch almost overnight, and can alter the way we use the street: a block with nothing that interests us can suddenly become a centre in our lives if a café we like opens or a clothing store that stocks the right kind of pants establishes itself. We'll register that kind of change for a little while, but then it eventually blends into our daily patterns and it quickly feels like it was always that way. We get used to things and adapt to change, though nostalgia tries to get us to hang on. But once change happens, the memories start to fall out of our heads as the present fills up the space.

We often think that the city has always been more or less like it is now, that change is a violent exception, but looking through Cummins's incredibly deep and wide archive of photos is a stunning reminder of how cities are always changing, always in flux. Through his photos, we can trace shifts in parking-meter fashion and awning styles over time. Imagine having a button we could push while standing somewhere in the city that would take us back in time a little bit. Click again, and we go a little further back, just to see what

was there, the stuff that mostly isn't written about in the official history books: a vague memory of a shop that was once here or a long-gone hairdresser there. These are fading ghosts on our mental maps. The photos in *Full Frontal T.O.* do that, let us look backwards and along the streets that we know casually, and force us to look a little deeper, read the landscape a little more carefully. Some change is so slight that before-and-after pictures become like that old Spot the Differences game.

This is a book about two things. The first is people, their whims and the choices they make, sometimes on the fly, in how our city looks. They decide if the fence stays or go, if the windows will be cheap or expensive, or if this part of the sidewalk is shaded and green because they planted trees and shrubs or if it's a concrete runway. The other thing this book is about is the economy of a city. Not Bay Street, though that's certainly a cousin, but rather the economy of neighbourhoods and how it ebbs and flows, knocked around by real-estate ululations, population flows and taste, and, yes, whether or not things are all right over on Bay Street. Sometimes the economy is stagnant, but other times it moves at the speed of a subway, as stores and restaurants change, seemingly overnight, to fit whatever the economy of the moment can afford. The relentless flux highlighted in this book's time-capsule nature makes you appreciate those things that have managed to last more than a few years.

All good cities have had photographers whose work explores its streets and buildings, telling stories along the way to help us figure out what that place is all about. New York had Weegee, who carried his big box camera deep into the Manhattan nights to catch cars smashed into poles and fists smashed into faces and the occasional paddy wagon full of transvestites rounded up in the bad old days when busting the kinds of human activity that had to hide out in bars after midnight was routine. Along the way, his black-and-white shots helped create the idea that the sirens were always screaming in New York. Western cities had photographers like Ed Ruscha snapping every building on the Sunset Strip in Los Angeles and Stan Douglas in Vancouver documenting every building on 100 West Hastings; they both delivered an idea of the expansive urban west with big signs and wide sidewalks. Then there is Paris, a city that has come to be the ideal of beautiful urbanism. Soon after photography became the dominant medium, Eugène Atget wandered Parisian streets, capturing city life and architecture, images that were exported around the world so that Paris lived in everybody's imagination, even people who would never visit. But Paris is easy to love.

Rough-and-tumble Toronto has Patrick Cummins, who has also wandered the city, in this case for decades, with camera in hand, first film and later digital. The human bodies that appear in his photos are incidental; the focus here is on the stories people in Toronto tell with the buildings they build. What sets this work apart is time. Cummins didn't just wander through the city once; he systematically returns to the same buildings or blocks, over and over, standing in the exact same spot, taking the same photo. Sometimes when he returns there are too many people out front, or a car or truck is in the way, so he has to come back another time. Rush hour is a good time to capture some of the main streets because parking isn't allowed then, but residential streets are trickier. There are cars in some of the photos, but that they don't dominate is testament to Cummins's persistent pursuit of his full-frontal treatment with as little distraction as possible. By mostly removing people from these photos, he allows us instead to see the things people do, and what they leave behind. Some changes are confounding, and others tell us a lot about how neighbourhoods have changed, ethnically or economically. These photos remain the

story of the people of Toronto, even if we can't see most of them.

Full Frontal T.O. shows how old Toronto has been dragged into the present day. Throughout these photos, the particular pre-war Toronto typology is evident. In an early study of what made Toronto Toronto – long before the city's own insistent navel gaze found on local blogs and in magazines – the Walker Art Center in Minneapolis turned over a 1978 issue of *Design Quarterly* to Toronto architects George Baird and Barton Myers, who looked, in part, at how this typology came about. They noticed that large estate lots, often with a manor house and grounds, from the mid-1800s until the Edwardian era, were divided in a way that gave Toronto the look we know today. Of this subdividing they wrote, 'the typical lot has a characteristic shape – long and narrow; a characteristic width – usually not narrower than 20, nor wider than 50 feet; and a characteristic depth – usually between 100 and 150 feet.' They went on to describe the typical building erected on these sites: 'long and narrow, front facing to the street, with service to the rear, and not less than two nor more than three stories high, excluding the basement.' This is the Toronto that was repeated, street by street, and it's the Toronto Cummins found on his walks.

You can start reading this book anywhere; there is no beginning or end. It isn't an exhaustive study of the city but rather the kind of random selection you'd find if you started a walk anywhere in the city (and had access to a time machine). The photos that follow are laid out in different ways. Some are shots of a single building or a row of buildings, going back in time – pictures move chronologically in columns, like you'd read a newspaper. Some pages show a block of buildings that were at one point identical; it's fascinating to see how radically different some are now. And some pages show a collection of typologies, including dead stores, functioning variety stores, Gothic and DIY cottages, semi-detached housing and garages.

The best way to discover the city is without a map, so there isn't one here either. It isn't laid out by street, by neighbourhood, by what's beautiful or by what's ugly. It's more fun this way, so start at the photo after these words, or open the book anywhere. It's all Toronto.

Along the way you'll start to see that Toronto, indeed, has a look of its own, and maybe this landscape we've been ignoring for so long, yearning for something more traditionally beautiful, is a gift to the city. The Toronto vernacular is a utilitarian, street-level mash of different iterations of classic Victorian, Edwardian and a few other styles of architecture, a kind of physical slang version all our own – identical buildings that, over time, have all changed in their own unique ways. Toronto's workaday buildings, we see here, have a nearly inexhaustible capacity for change, to adapt to new needs – they aren't too precious to resist alteration. The 'sticks' that Brigitte Shim mentioned are secretly resilient and robust, a plain, ordinary, everyday base to try new things. This is not to say we should stop craving beauty, whatever that is, but the vast parts of this city of heterogeneous streetscapes with buildings that don't match at all but seem to get along next door to one another let people do their thing and come up with new ideas. The past here in Toronto isn't as heavy a weight as it is in other places whose greatest days are behind them, where the architecture is forever reminding everybody of those days. In Toronto, our architecture and infrastructure are forever trying to catch up to the city we have become. Wherever your eye lands in these photos, our heretofore nondescript streets have much to look at, whether it's comparing photos of the same place taken at different times or investigating a block facade by facade. This is the Toronto we know and have known, even if we didn't know it.

Full Frontal
T.O.

140 Boulton Avenue

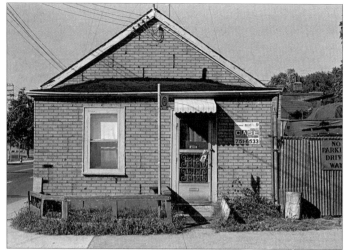

1980

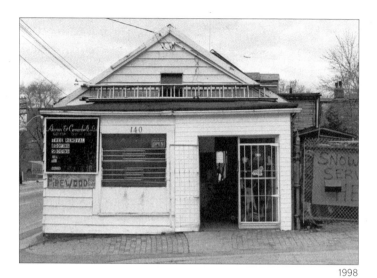

1998

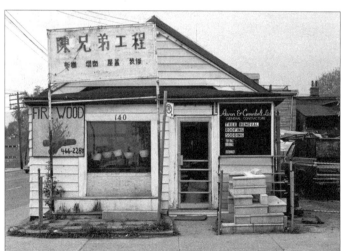

1988

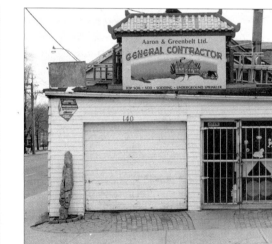

1999

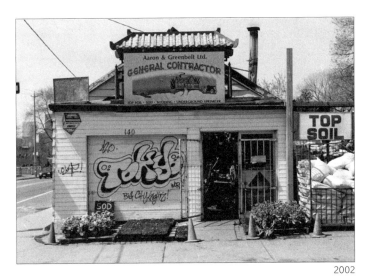

2002

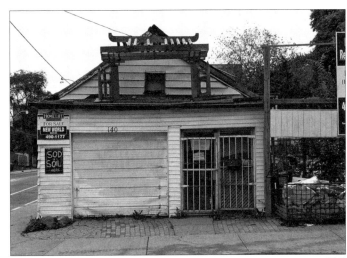

2010

2007

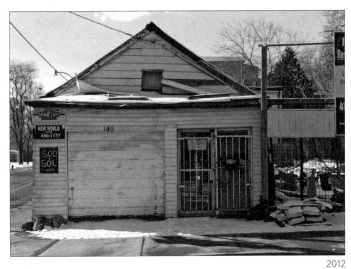

2012

447–457 Bathurst Street

1997

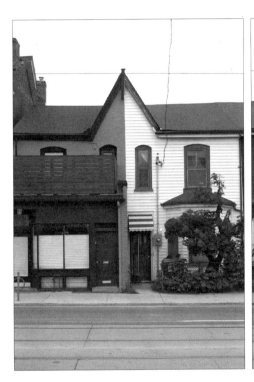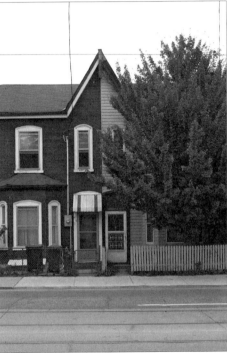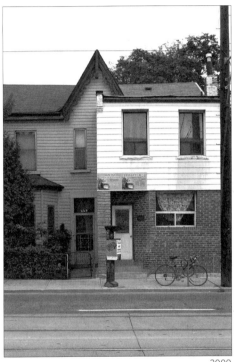

2009

Along the tougher length of Bathurst south of Davenport, there are signs of a genteel Victorian past that has been overrun by the heavy traffic. House facades have become tough and thicker, like the face of a person who has smoked his whole life. The stretch between College and Queen has a particularly hard urban quality. In this stretch, like on many arterial roads across the city, residential streets have become retail shops, with fronts that have busted out to meet the sidewalk. Here, though, the market gives little concern about architectural purity, and gingerbread peaks are blocked by aluminium-sided boxes and do-it-yourself railings, and cheap trim replaces craftsman details on these homes. But the arched tops to all the windows are original and remain largely consistent, even as the siding changes and glass is replaced: the bones, they're solid.

618 Richmond Street West

Drivers ripping down Richmond approaching Bathurst don't have their eye on this Gothic cottage beauty on the north side; they're thinking of making the light and getting to the Gardiner. This cottage has quietly watched the traffic go by and its once-dowdy, light-industrial neighbours become art galleries. Change here was subtle until the siding was added; trees got fatter, doors were replaced.

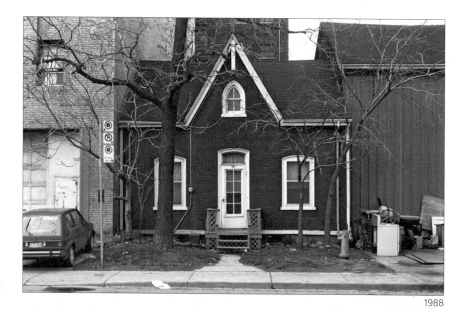

1988

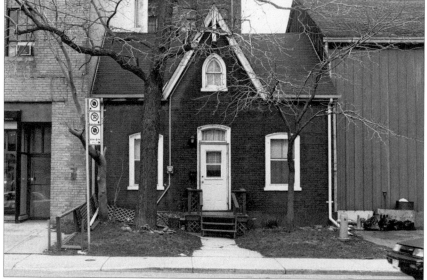

1998

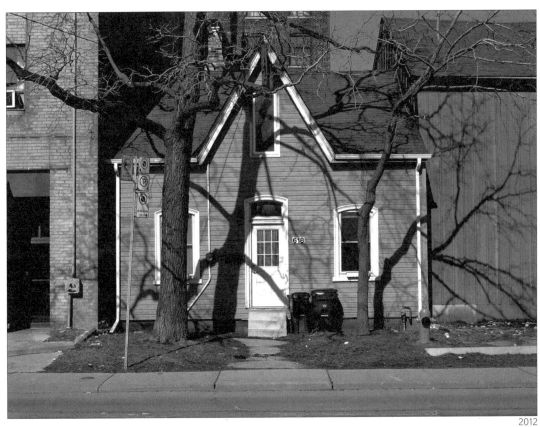

2012

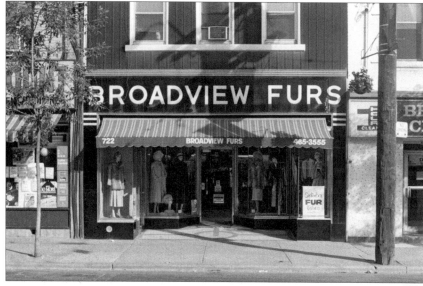

1988

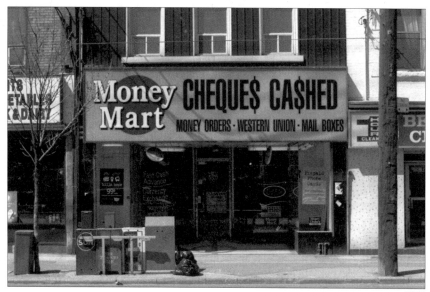

2001

722 Queen Street East

When Cummins took the first photo in 1988, Broadview Furs was in the twilight of its days and one of the last Vitrolite beauties on the Toronto streets. The three-line motif on either side of the store, a 1930s Streamline Moderne trope, is still visible on the left side of the one-size-fits-all Money Mart sign, a retail vulture if there ever was one. While furs may not have given much back to the city but unnecessary pelt-wearing, the Money Marts are a sign that all is not stable in a neighbourhood, and profit is being made off people's financial insecurity. Still, that Vitrolite was applied with great globs of adhesive, and still might be under this sign that could disappear without a tear as soon as someone is willing to make an effort.

515 Queen Street West

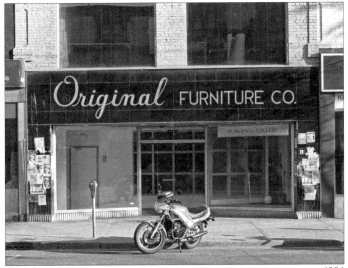

1984

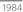

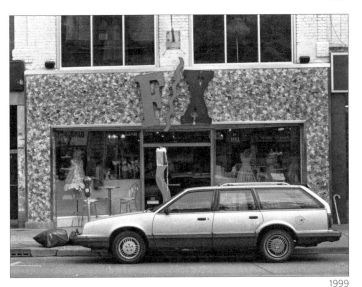

2011

1999

The original Original was already gone by the time Cummins took the first photo in 1984, but the S.L. Simpson Gallery was there, part of the early eighties Queen West art scene. The Vitrolite was too, those British-made glass tiles that once were ubiquitous across the city, on our storefronts and in our subway stations. The original 1954 subway stations were all lined with it but only Eglinton still is, and Broadview Furs, opposite, like Davisville, Rosedale, College and the rest, isn't. And some typefaces are worth returning to.

248 Hallam Street

This was a complete makeover, from pleasant to fortress in a decade.

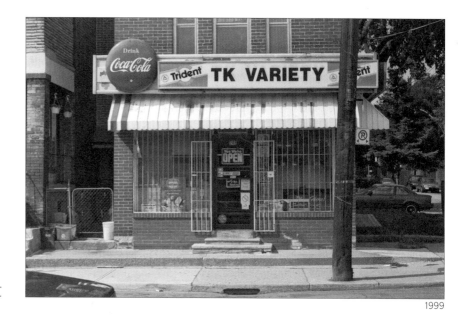

1999

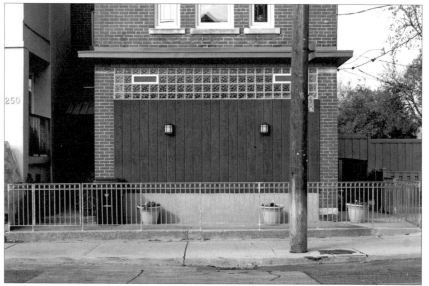

2009

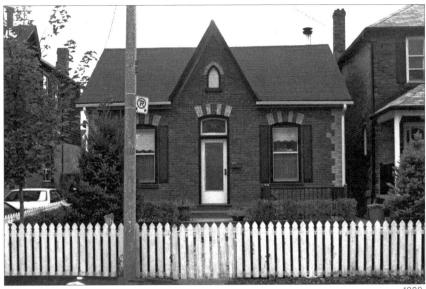

1988

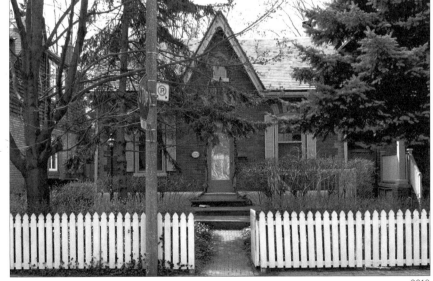

2010

120 Pape Avenue

Toronto has many old cottage-size houses, but those with the peak over the front door – intended to protect the entrance from the elements – are known as Gothic cottages. Gingerbread and poly-chromatic brick are often present.

800 Queen Street East

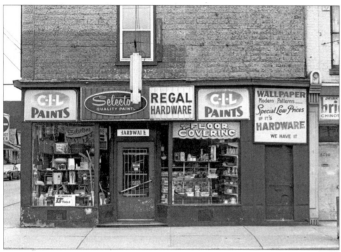

1980

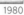

2007

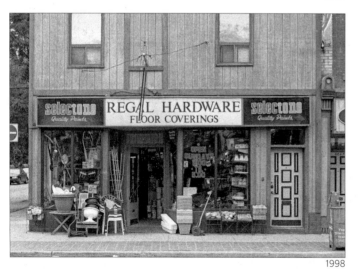

1998

Lots of change but the name remains. In the second picture, windows ubiquitous to Toronto have appeared. They're for child safety: small enough to avoid falls, but big enough to allow in a passable amount of air (but not an air conditioner, something landlords who don't charge for hydro like). If you've ever lived with one, in a hot second or third floor of a house, you'll likely have pined for the old-fashioned windows that opened far enough to stick your head out. It's good to stick your head out of a window sometimes because, apart from looking out of, that's what they're made for.

127 Strachan Avenue

Popular toward the end of the nineteenth century, Second Empire structures were built all over Toronto. For a time, Second Empire was the style of choice of the Canadian Government. Maybe the best way to tame it, or a parking spot, is to eat dinner in it.

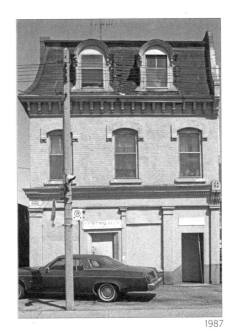

1987

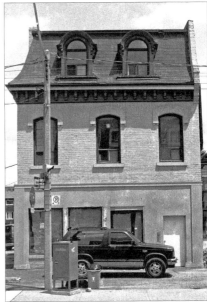

1999

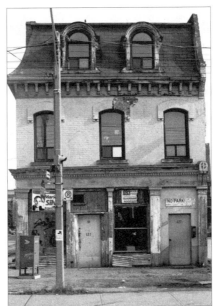

1998

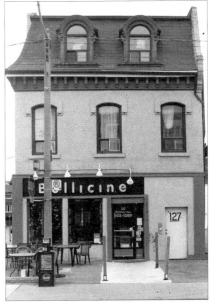

2002

799–811 Queen Street West

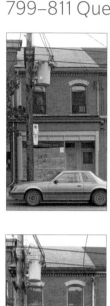 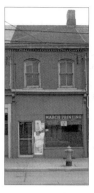 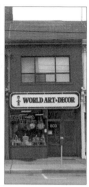 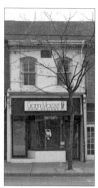 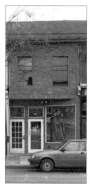 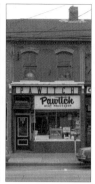 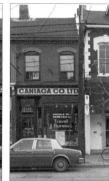

1987

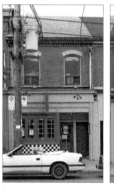 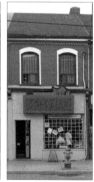 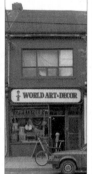 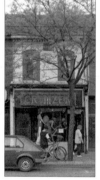 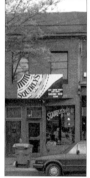 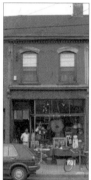 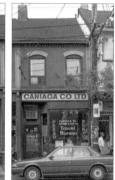

1997

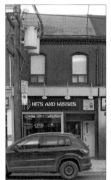 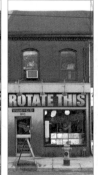 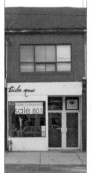 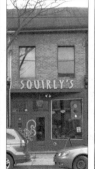 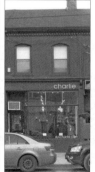 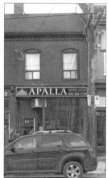

2012

181–187 Dundas Street West

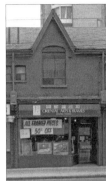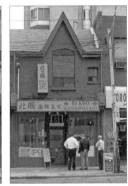

1997

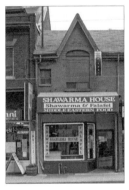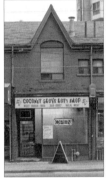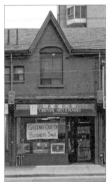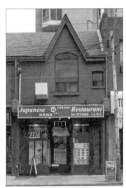

2000

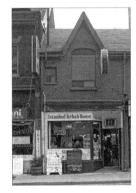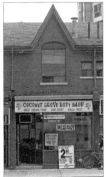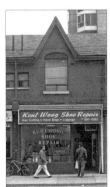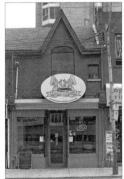

2004

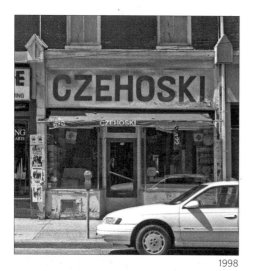
1998

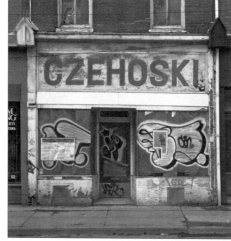
2003

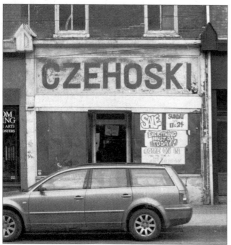
2002

2012

678 Queen Street West

Tags here by Jafar and others. The only tags at this location currently are late-night hipster Facebook photo tags of folks drinking at the restaurant and bar it became. For a time, the widow who lived here, after the Czehoski butcher shop was closed, could be seen late at night sitting inside or standing in the window in her housecoat watching early 2000s Queen Street go by. If you were here in 2000 or 2001, you probably walked by her staring out at you at night.

Gothic Cottages

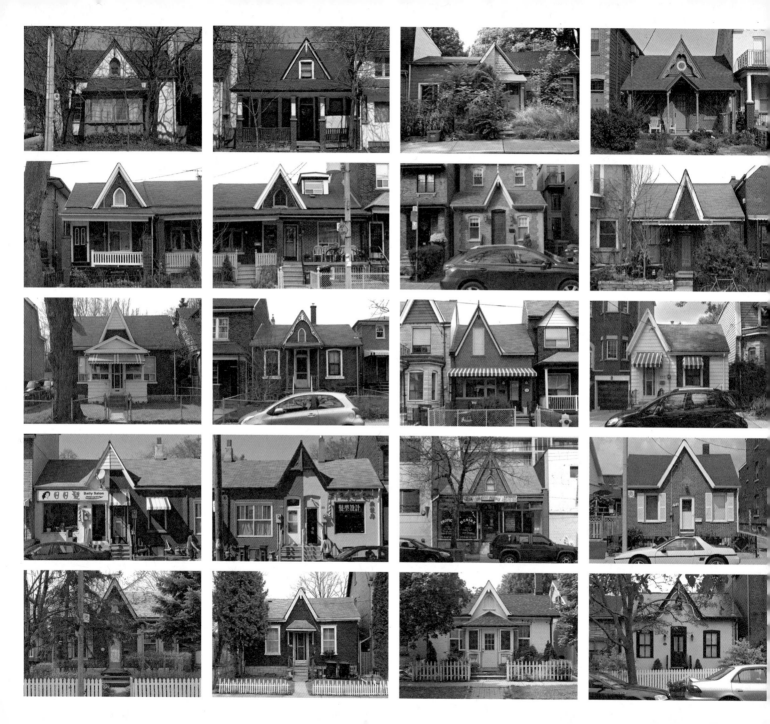

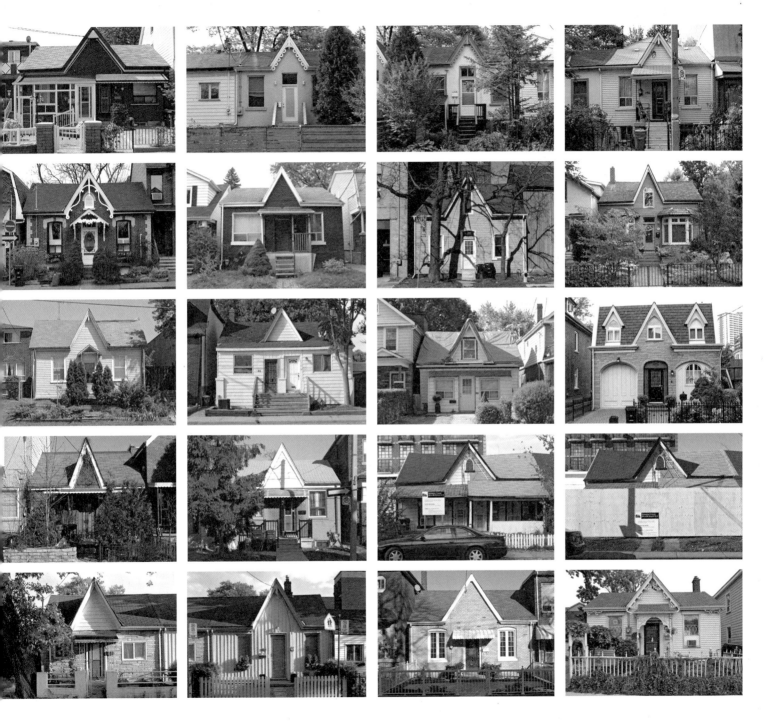

DIY Cottages

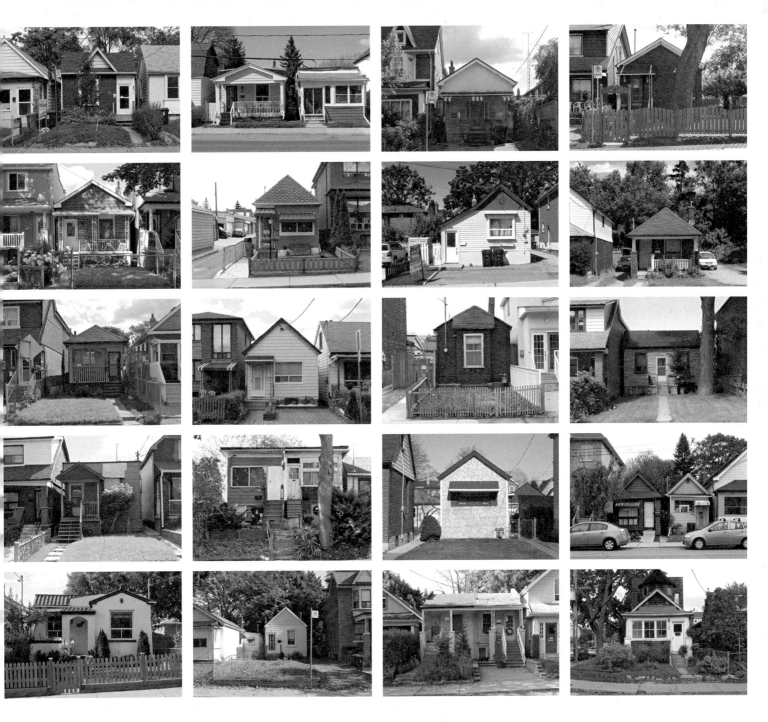

39 Gladstone Avenue

The neighbours lie awake with worry every night, waiting for the arsonist to accept the invitation. The invasive 'Tree of Heaven' weed tree sneaks through quickly for a spell.

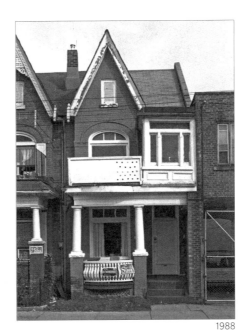

1988

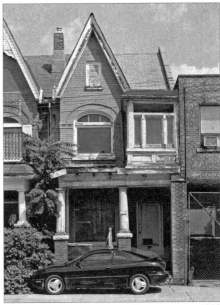

1999

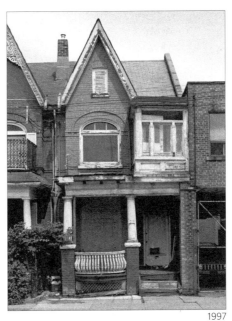

1997

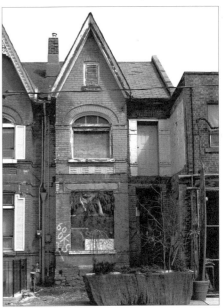

2009

320–322 Richmond Street West

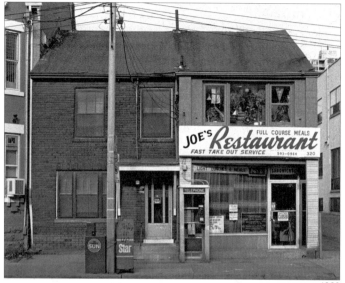

1983

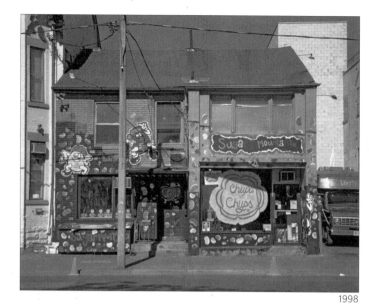

1998

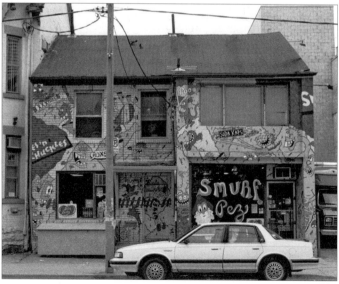

1998

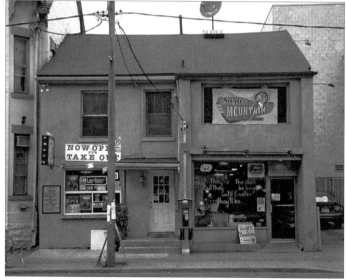

2001

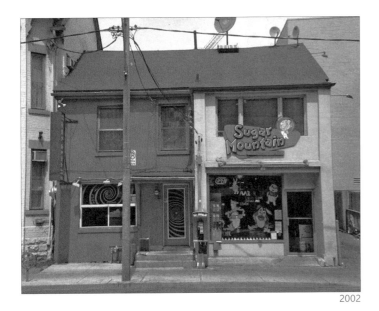

2002

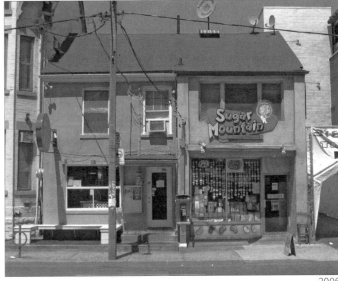

2006

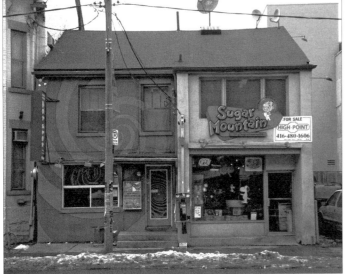

2003

Likely never a healthy location, a workaday restaurant becomes candyland as the warehouse neighbourhood around it becomes Clubland. There's a hardness to the buildings in Clubland, especially the (formerly) residential ones. Who could ever sleep in a second-floor bedroom here? At midnight on a weekend night, it's nearly impossible to imagine that people not lit up on expressways of alcohol and freelance-prescription pharmaceuticals once called this place home.

381–411 Jones Avenue

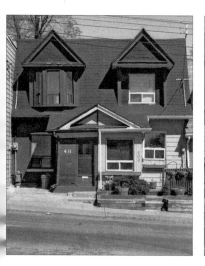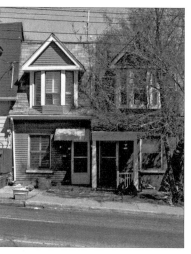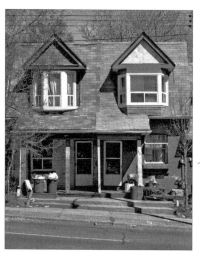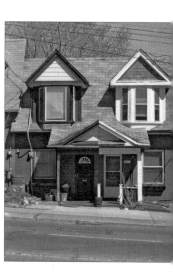

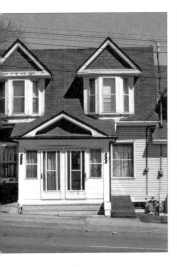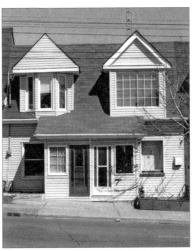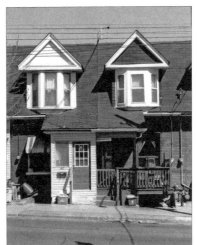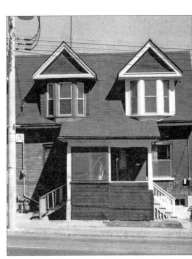

1999

It's all downhill on Jones. Everything in Toronto slopes slowly toward the lake, but on streets like Jones we can really see it. They'd have been identical when built, but porch and window treatments have changed them. Enclosed porches like these are always a sign of a busy street. This vernacular, plain style of housing is found across Toronto, in between fancier neighbourhoods like the Annex, Cabbagetown and Riverdale. It's this vernacular that's the mortar of Toronto.

227–229 Church Street

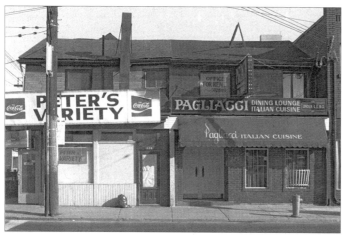

1983

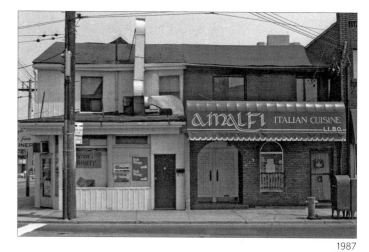

1987

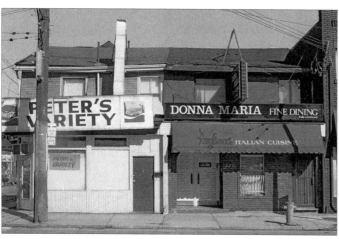

1986

1997

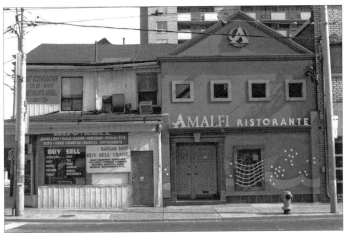

2002

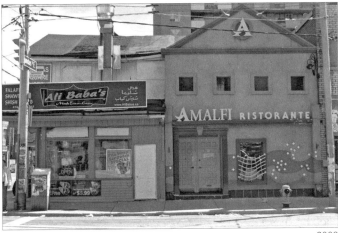

2009

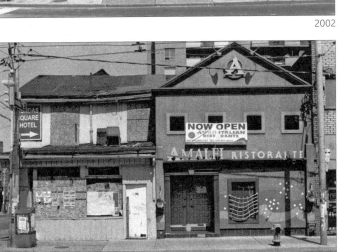

2007

Here's Toronto's do-it-yourself typology at work. Two old buildings, the common 'sticks' that Brigitte Shim refers to, enduring much longer than ever intended, become the bones of the city waiting for whatever skin the current owner wishes to apply. The exhaust vent over Peter's Variety, from Pagliaggi next door, realigns at one point, disappears entirely, then eventually reappears. What's left on the second floor, behind those boarded-up windows? Second floors are the mystery spaces of the city. Stare at them from the streetcar at night, when you're closer to their height, and catch fishbowl glimpses of their interiors.

118–124 Argyle Street

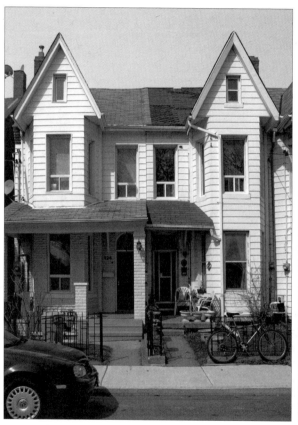 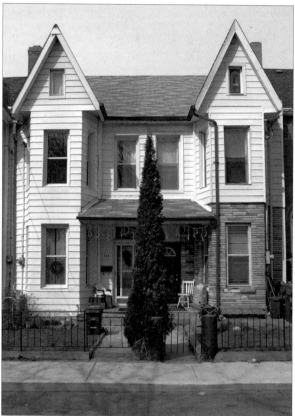

2010

Tall, noble, but not particularly fancy, as whatever ornamentation was there has been stripped. A porch addition, a roof in need of shingling, aluminum siding and a bit of 'angel stone' turned a row of once-identical houses into individuals. The same will happen in the monotone suburbs in twenty or fifty years; these are not unique.

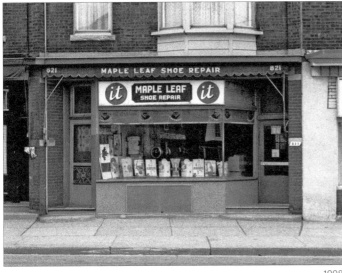

1998

821 Lansdowne Avenue

'It' shoe-polish signs were once as ubiquitous as Coke and Kit Kat signs are now – the shoe-repair shops they appeared on were far more plentiful than they are now.

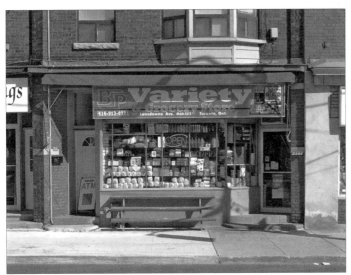

2009

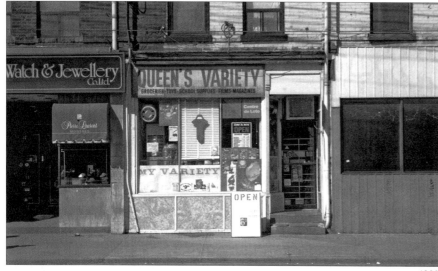

1999

976 Queen Street East

The end of Toronto's unanimous monarchism, as Queen becomes the more republican 'My' variety. Nestlé got into the sign-sponsoring game after cigarette advertising was banned. In the bottom photo are tags by Skam, Horus and others.

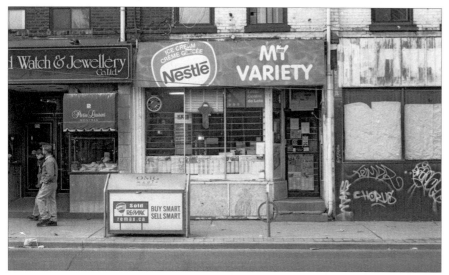

2003

621 Bathurst Street

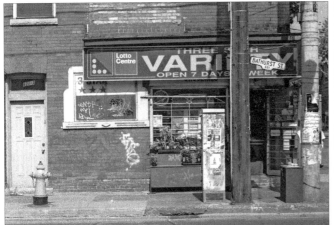

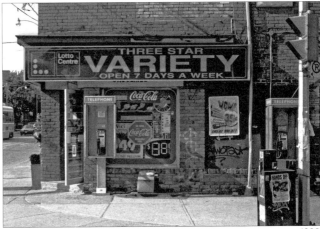

1998

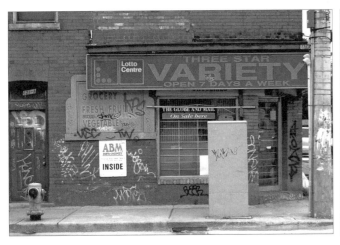

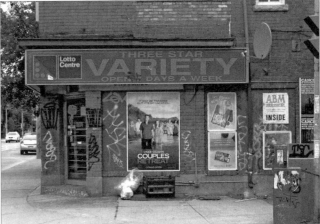

2009

A wood-framed chalkboard from the 1930s was painted over eventually, and half-hidden behind a one-size-fits-all Lotto sign. Poles come, poles go. Who needs that public phone anyway? Two of them, in fact.

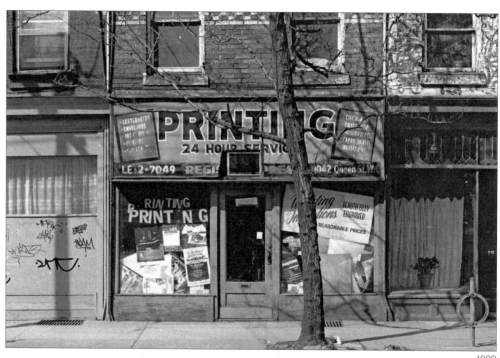

1999

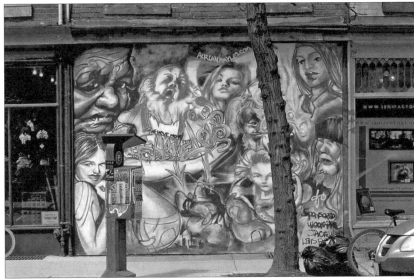

2009

1042 Queen Street West

With a sign like Printing, this place was just asking for it. The tags on the left were all common in 1990s Toronto, including one by Skam. The top mural was by Adrian Hayles, the bottom, Alexa Hatanaka in collaboration with Logan Miller and Kellen Hatanaka. Part of so many lives as they passed by, ephemeral work like this, loved by some, hated by others, tends to remain anonymous to most.

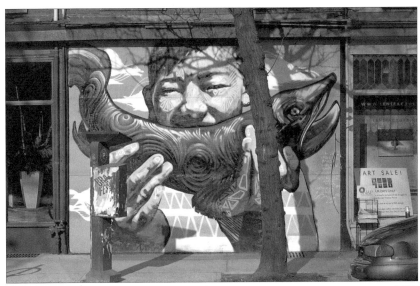

2009

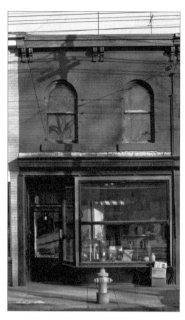 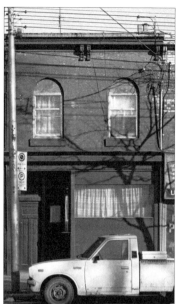 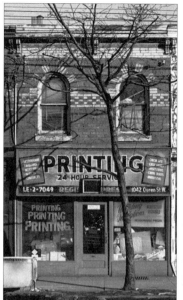 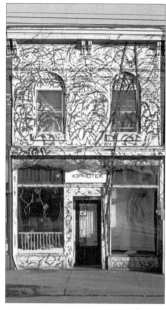

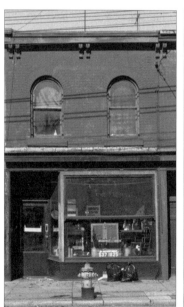 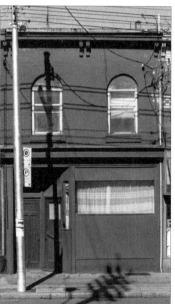 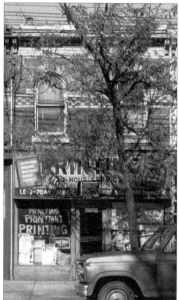 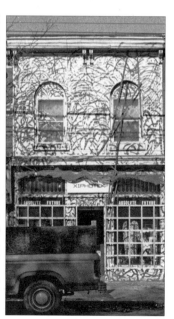

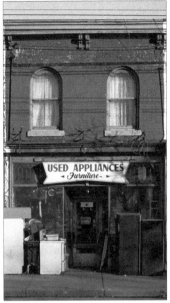
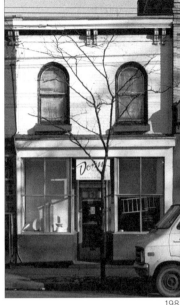

1988

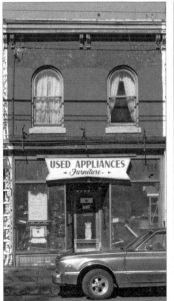
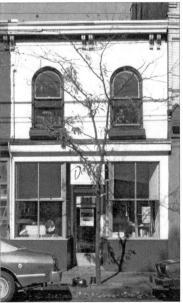

1989

1036–1046 Queen Street West

Xiphotek was a Queen West gallery in the 1980s art scene. Rapid change everywhere, except for 'Printing,' until the time when shops like it were no longer needed. One owner, likely, as the original bricks above were never painted over.

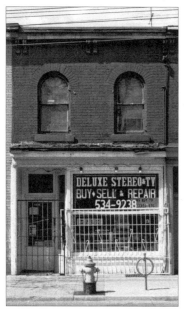 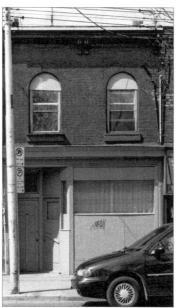 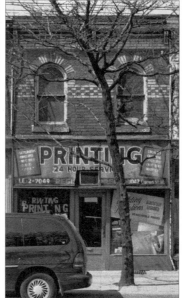 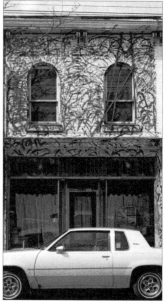

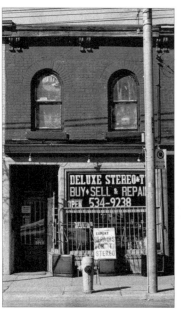 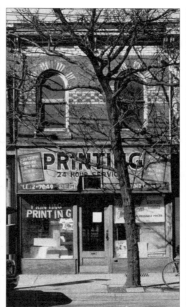 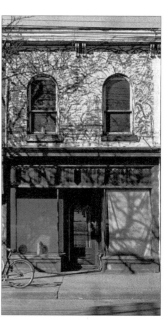

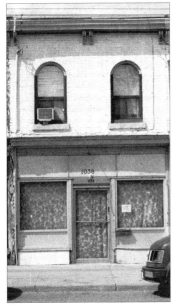 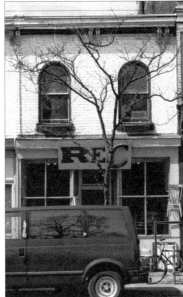

1998

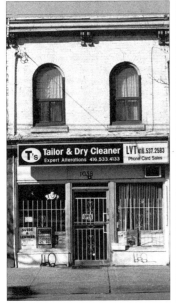 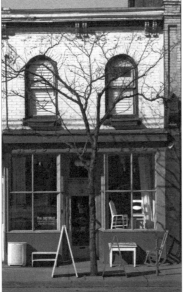

2004

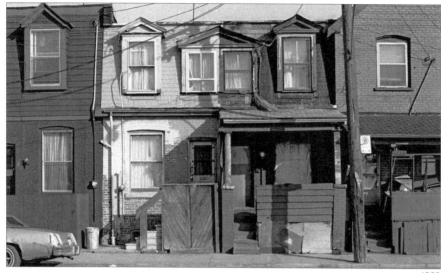

1983

39–41 Broadview Avenue

Like an infectious cold, decay can spread. Things fall apart and the centre does not hold.

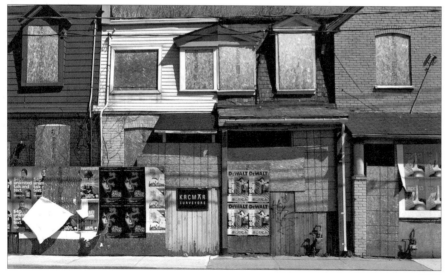

2010

Dead Stores

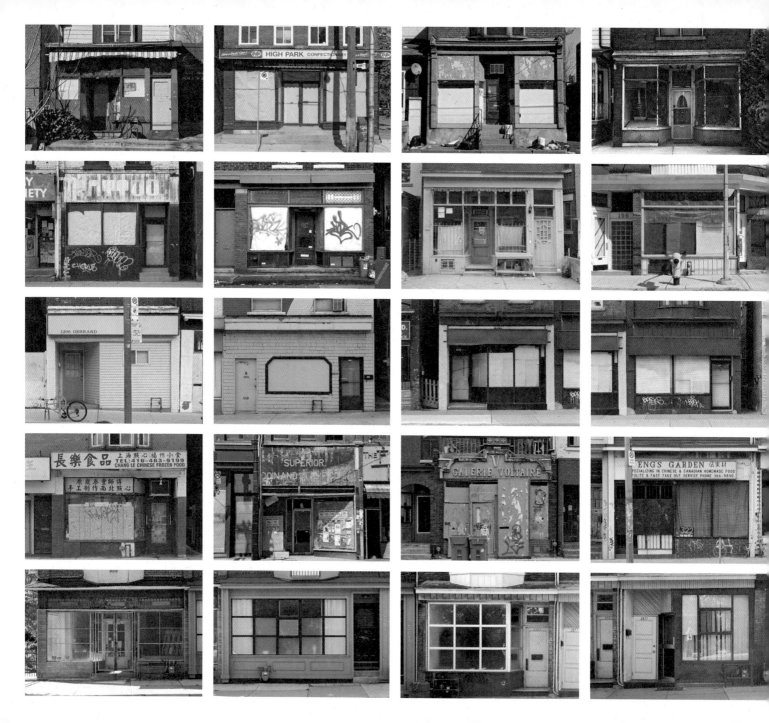

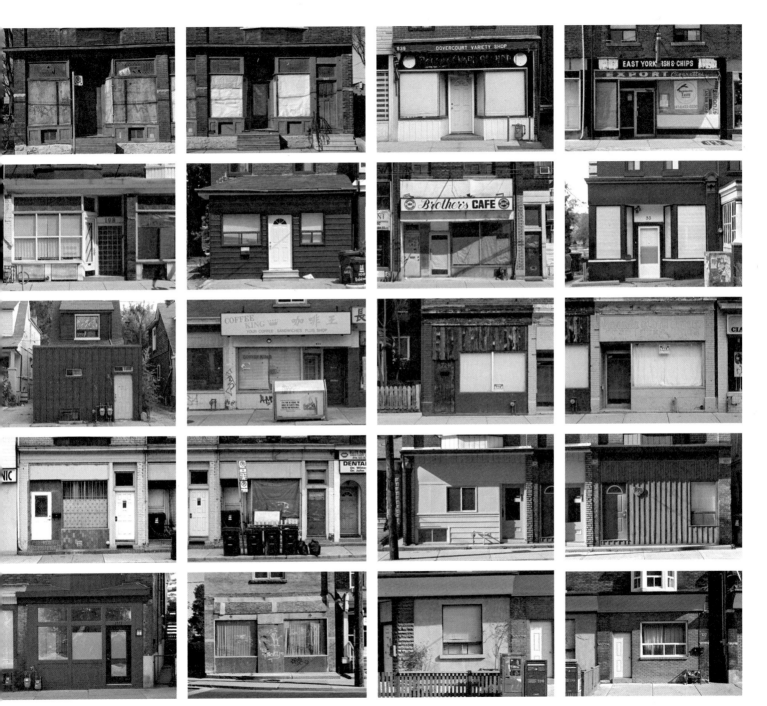

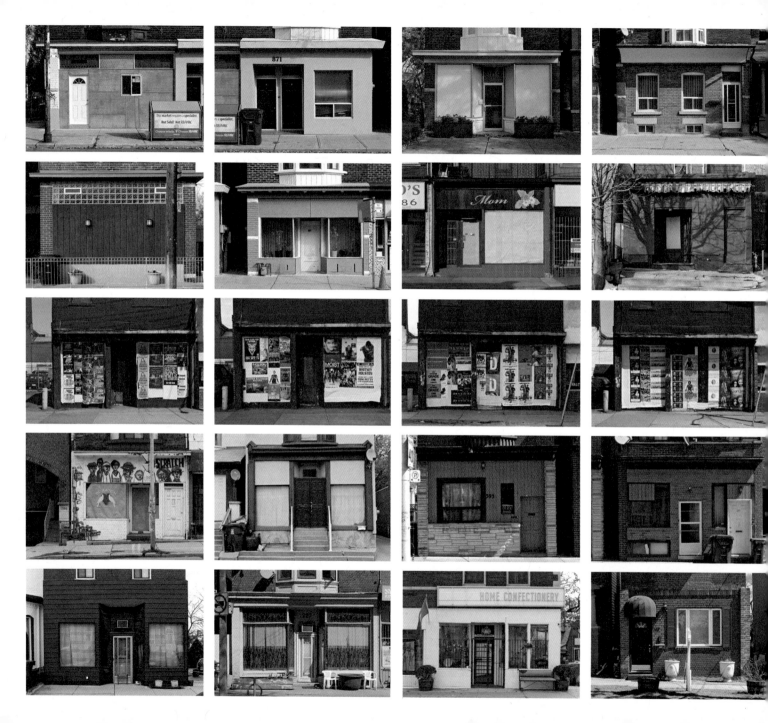

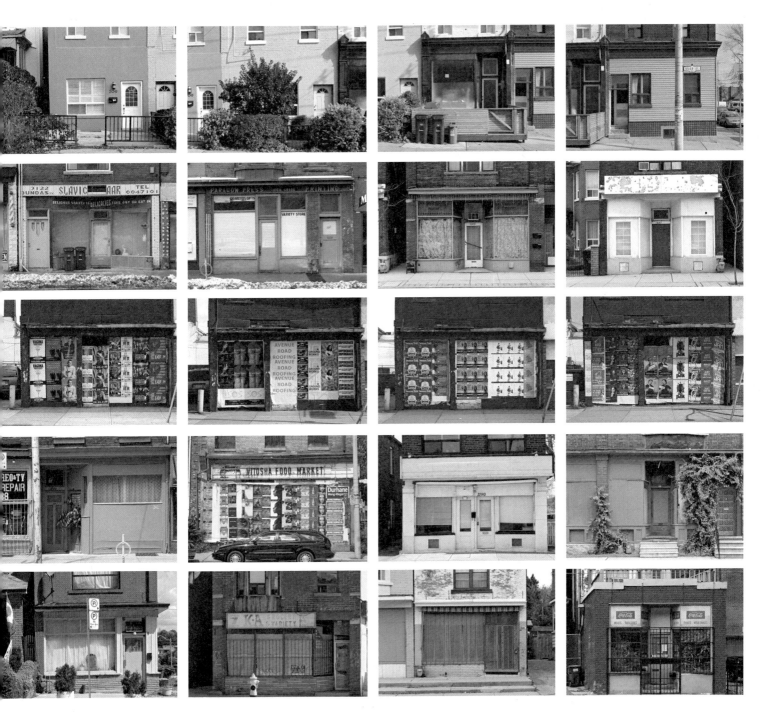

224 Adelaide Street West

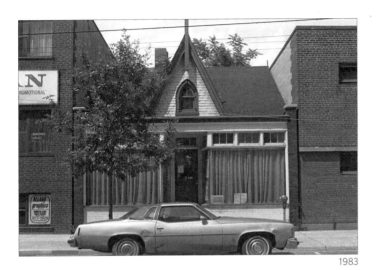

1983

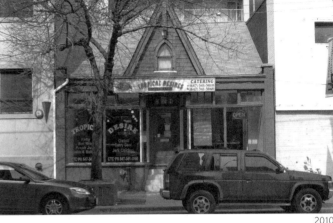

2010

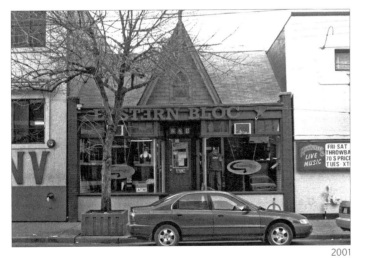

2001

A rare Gothic cottage survivor in Clubland. Residential homes in this loud part of town continue to exist even as 50,000 or more partiers descend on the area every Friday and Saturday night, though generally, as here, these homes were converted to commercial uses.

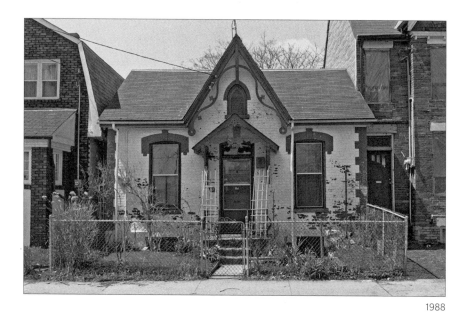

52 De Grassi Street

Another street, another Gothic cottage. More care has been taken here as it's on desirable De Grassi, the most famous street in Canada. An earlier paint job from a down-at-the-heels era has been sand-blasted down to the original polychromatic bricks. All over Toronto these bricks are our workmanlike building material, often yellow and red but sometimes with a little black creosote sprinkled into the mix. These bricks were most often made locally, at brick yards found across the city, including the most prominent, the Don Valley Brick Works. A chain-link fence, the scourge of the urban landscape, has been removed and a garden planted. Kinder, gentler, this worker's cottage has been faithfully restored. Victoria would be proud.

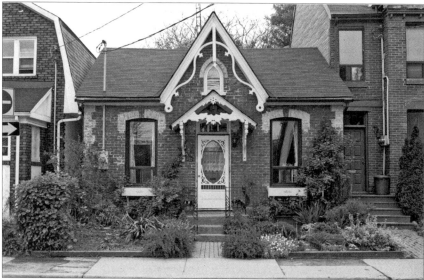

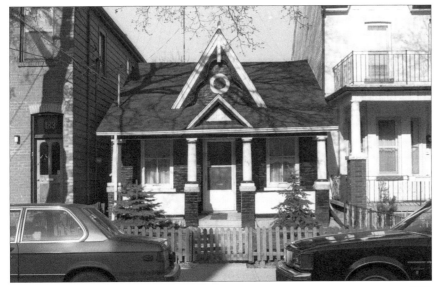

1988

181 Lippincott Street

Sometimes a house gets regingerbreadized.

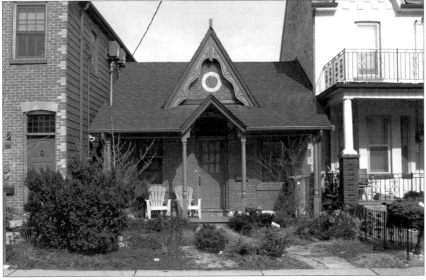

2010

1983

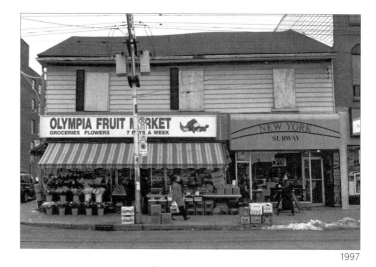

1997

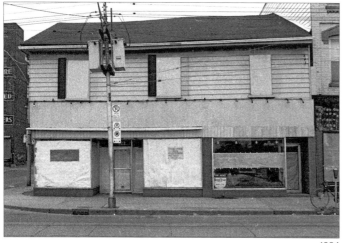

1984

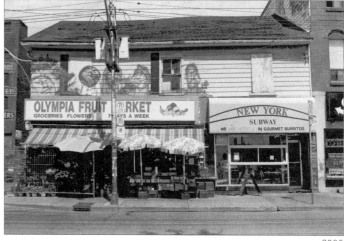

2006

58

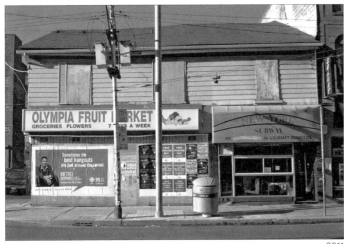

2011

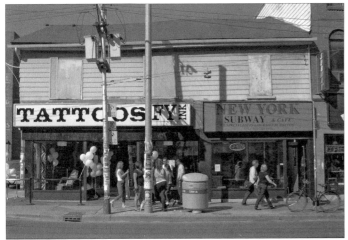

2011

520–522 Queen Street West

New York Subway is a study of an indie shopkeeper keeping up. A subway joint before there was Subway, which conspicuously moved in next door, NYS added a line about 'gourmet burritos' to their sign, free-market differentiation at work. Above Olympia for a time, after the windows were boarded up, sealing in yet another second-floor space, Toronto street artist Elicser painted a mural that was removed before the tattoo parlour moved in, though it would have been quite complementary.

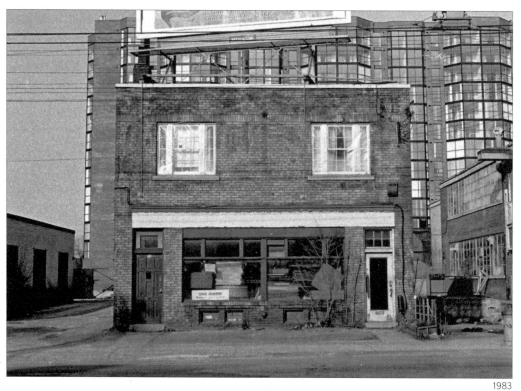

1983

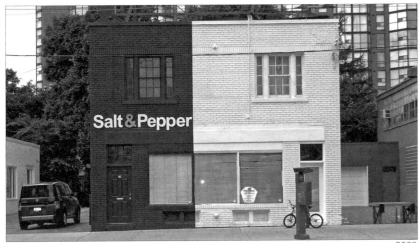

2009

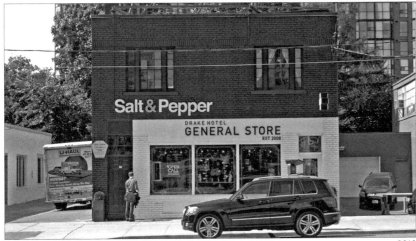

2010

82 Bathurst Street

Cummins lived on the second floor, here on once-Spartan Bathurst. Things were actually made in this part of the city (or broken things were fixed up). The nail guns from the furniture upholsterer below could be heard all day long in the apartment above. Behind is the Summit, part of the first wave of condo building three decades ago, before we perfected the repeating glass box form. Over time this location may have gotten fancier, but it's the trees that make the difference.

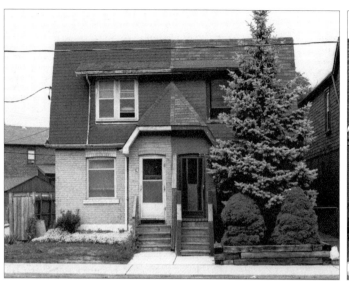
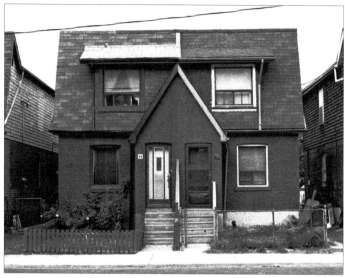
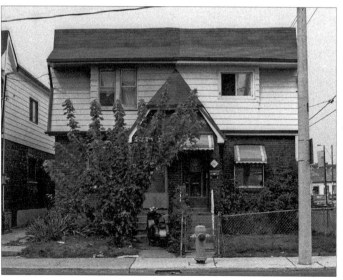
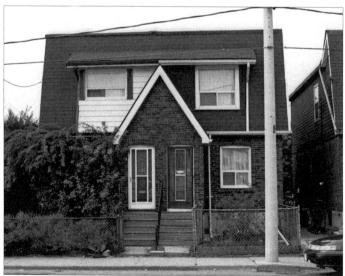

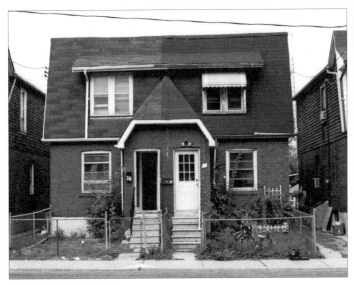

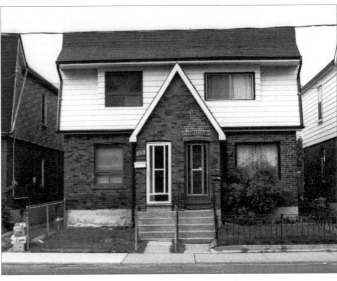

Sometimes a peak just wants to peek,
other times it's a little hooded.

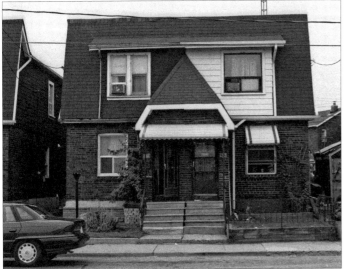

1998

272–274 Queen Street West

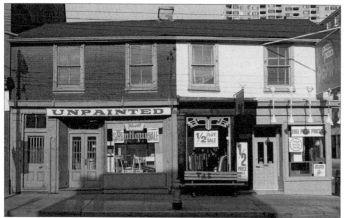

1983

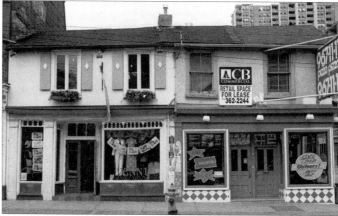

1998

1988

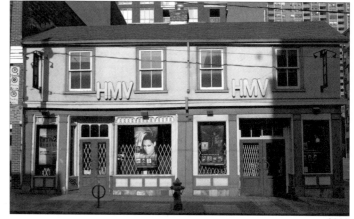

2009

The ground floor may change, but remarkably, the blind in the upper window stayed in the same exact state for twenty years, until HMV carved out both structures for their store. Unpainted became very painted, but a vestige of the cigarette days remained with the Player's logo, and vestiges of another ending era remain in a store that still sells CDs.

205 Brock Avenue

Part of a row that was once all stores, this one was the last to go.

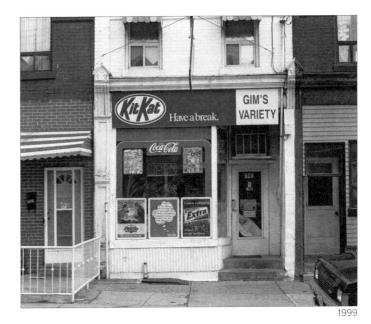

1999

2009

 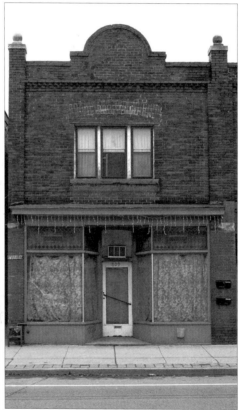 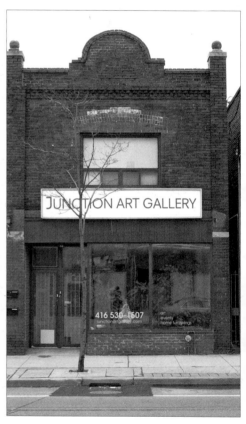

1607–1617 Dupont Street

The Edwardian era, before World War I, was more austere than the preceding Victorian, but they still had cornices with balls.

2010

920 Queen Street East

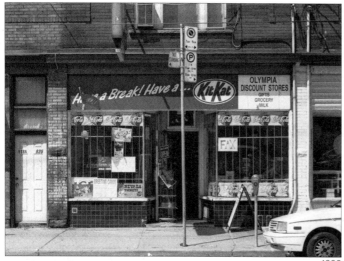

1998

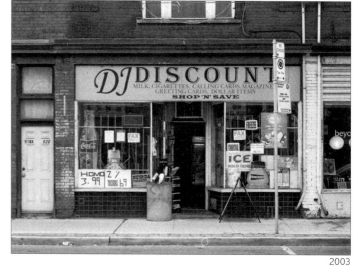

2003

A quick-change artist, moving at the speed of the economy.

1999

Semi-Detached Houses

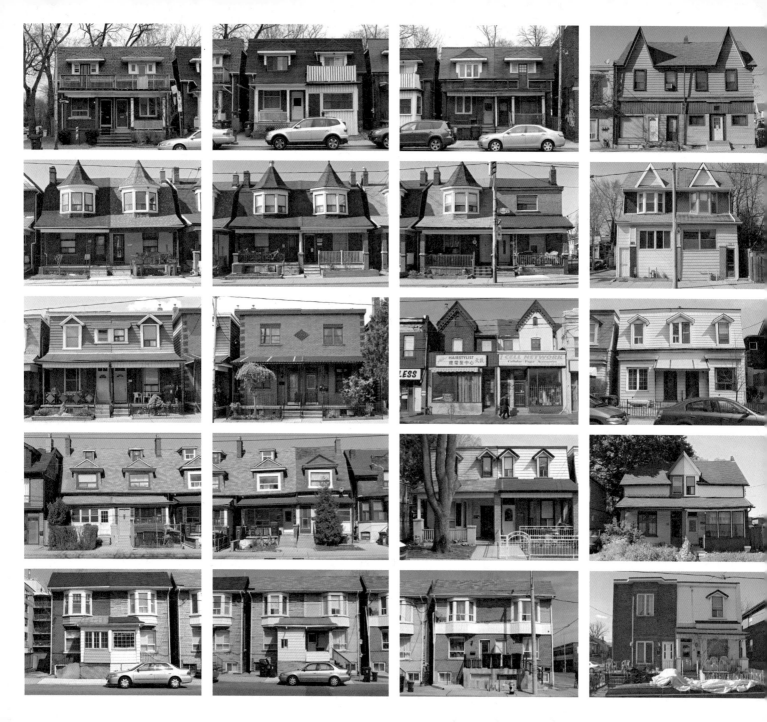

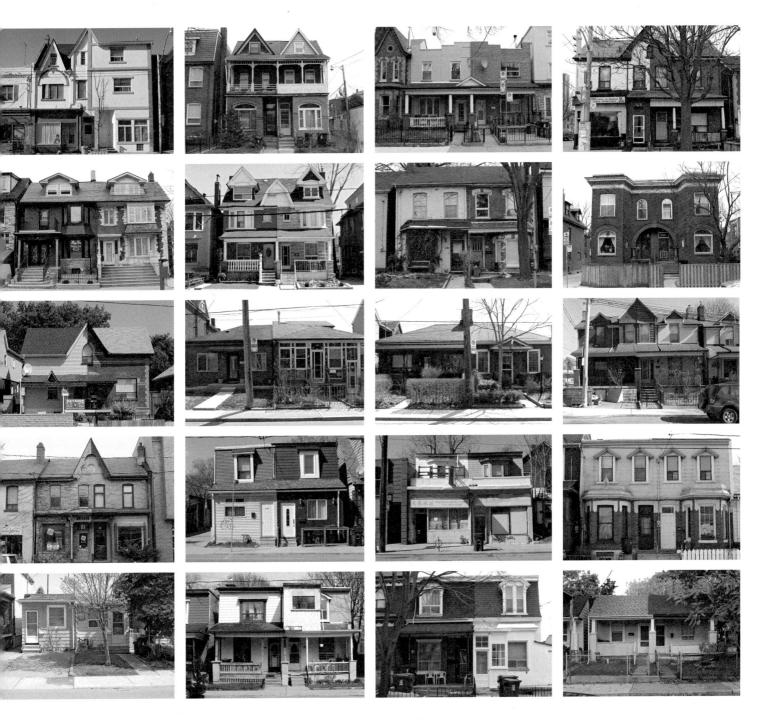

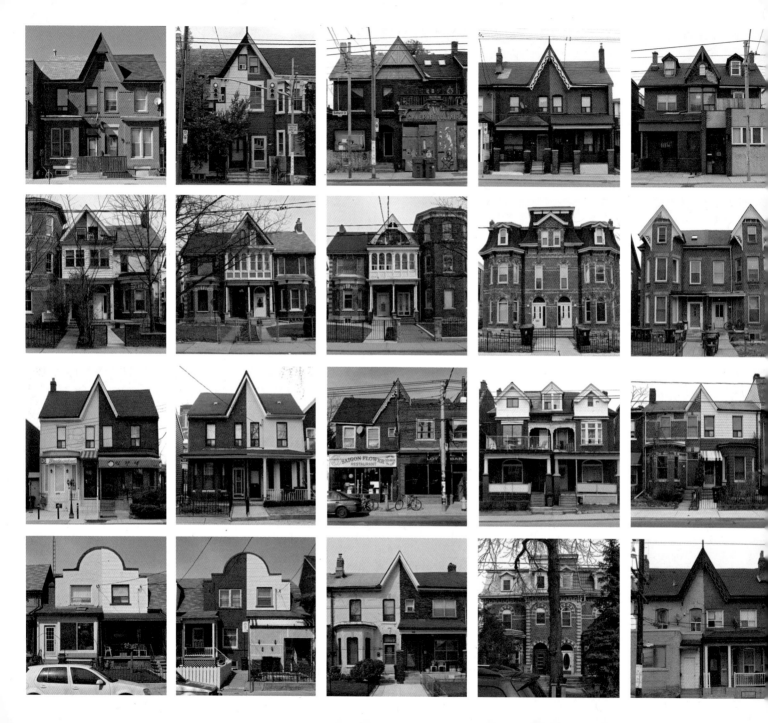

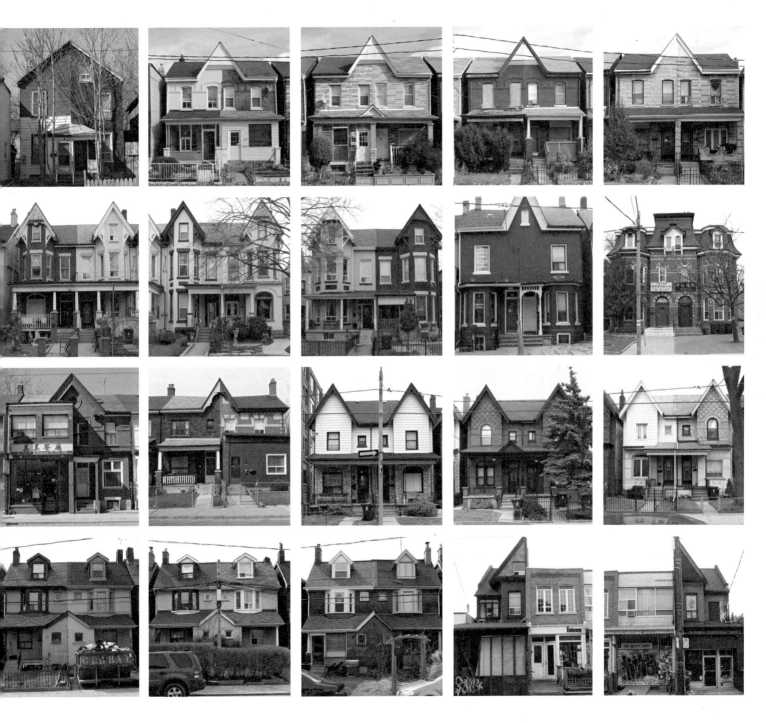

429 Bathurst Street

Toronto doesn't do Rust Belt decay much but for a few rare examples like this. Whoever lived on the second floor endured a while, until at least the second-last picture. The cat in the window seems sanguine about it all, and as it went, so too did the radiator shop next door, but that hole was filled in. The life is exhaling out of this house.

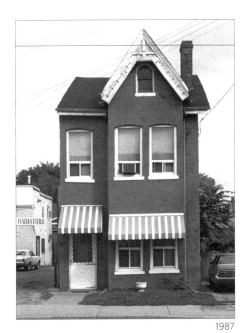

1987

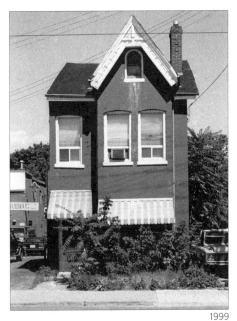

1999

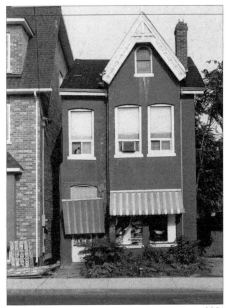

2000

2001

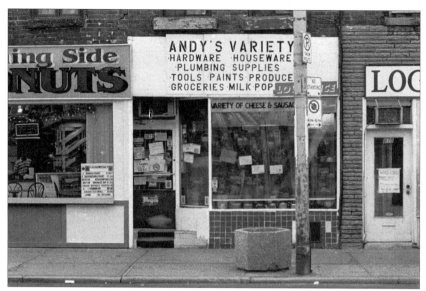

1999

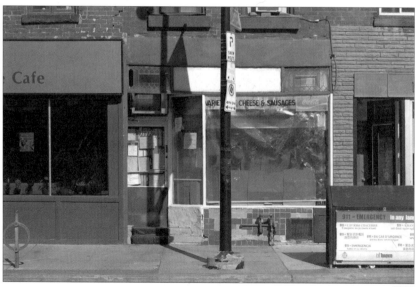

2009

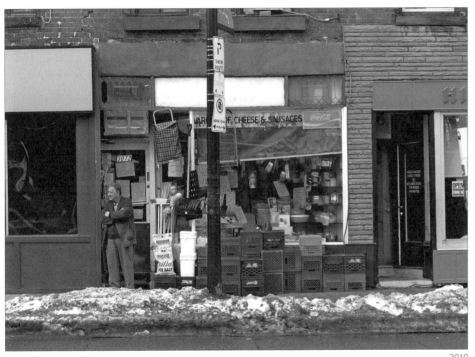

3072 Dundas Street West

Andy, what happened? Not your father's variety of cheese and sausage.

2010

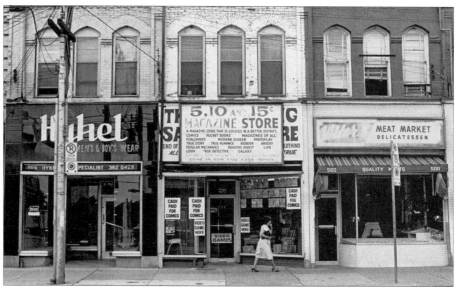

1983

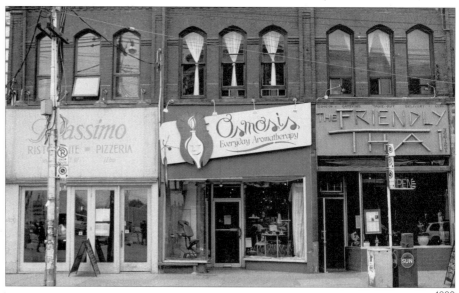

1999

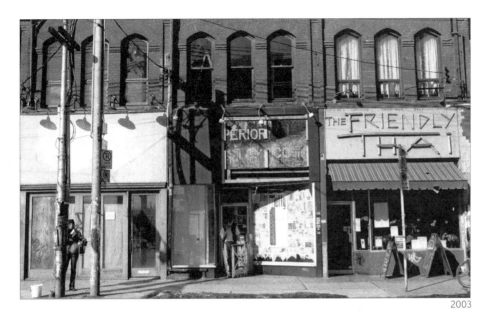

500–504 Queen Street West

Some family businesses fade away, and so too does the Vitrolite, though it might be hiding under some of that plywood, if we're lucky. Layers of signs advertising magazines that don't exist – and for a brief moment a glimpse of the Superior Stamp and Coin layer – give way to awnings and more affectionate treatment. If we didn't know better, we might also think Toronto is pole crazy – why have one pole when you can have two? Somebody should run for mayor on that platform.

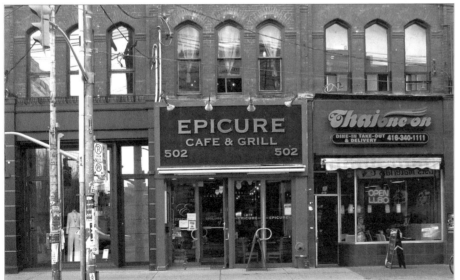

782 Dovercourt Road

A hand-painted sign gives way to a machine-made sign.

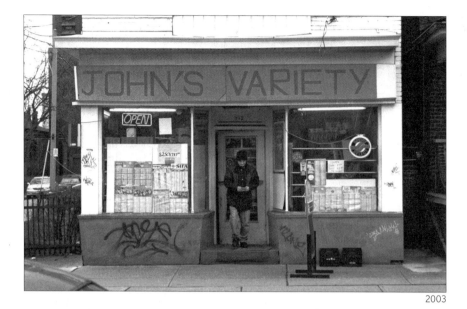

2003

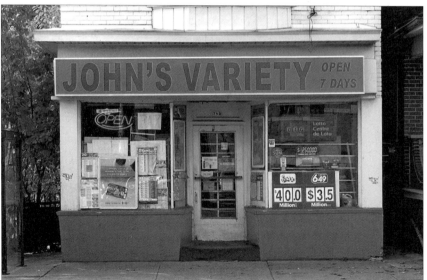

2009

1059 Dufferin Street

The doors have come forward and somebody's moved in. Domestication.

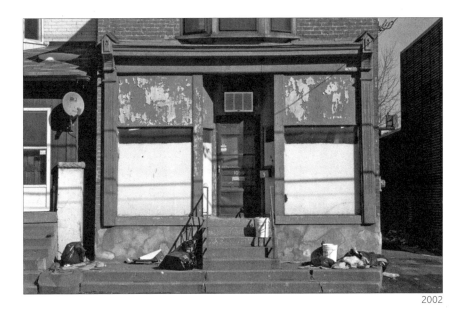

2002

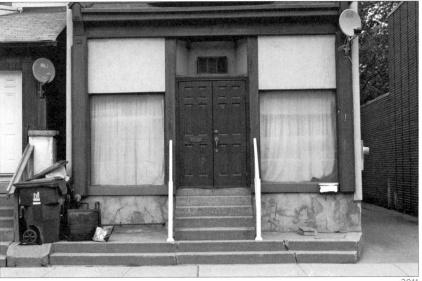

2011

478–480 Queen Street West

Extremes. One of the last vestiges of the Spadina corridor fur trade becomes a vegan restaurant. Rolled up, and not used enough, is another vestige: that striped awning over the convenience store. Once, Torontonians could walk an entire block and be protected by a continuous series of roll-out striped awnings like this, but inexplicably they have disappeared from our streets, though the sun still shines and the rain still rains.

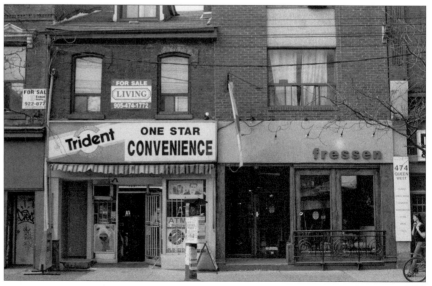

1983

2003

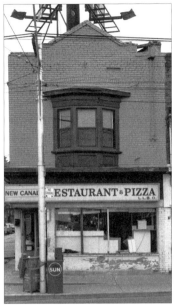
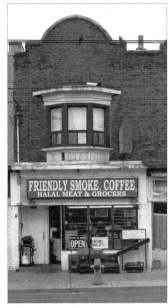
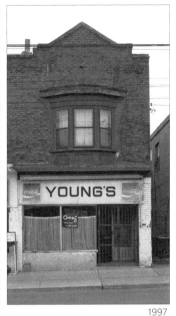

1997

1338–1342
Gerrard Street East

The Toronto ethnic shuffle.

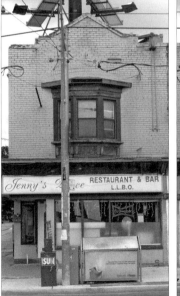
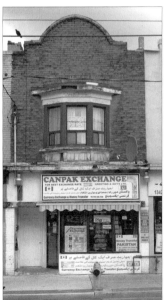
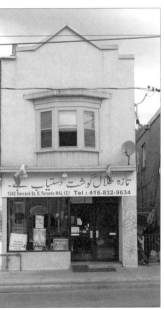

2009

395 Pape Avenue

Along this stretch of Pape, just north of the railway line – another big downhill – a row of former storefronts has been converted to residential. Once an at-grade crossing, the closing of Pape and the traffic re-route to Carlaw changed shopping patterns. South of the tracks, across the Gerrard Square mall, the Pape retail is still a going concern.

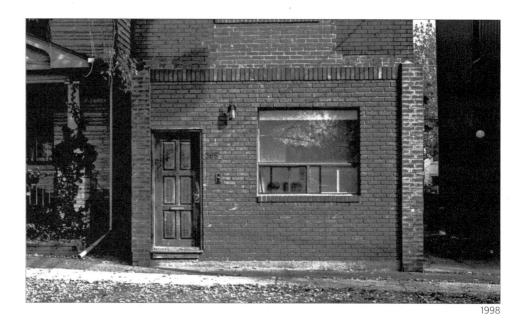

1998

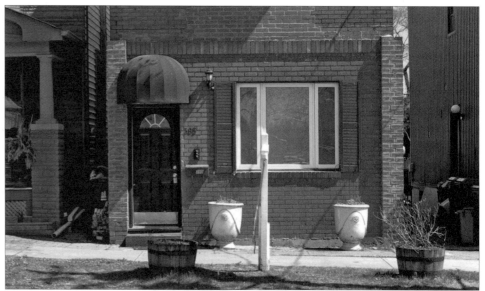

2010

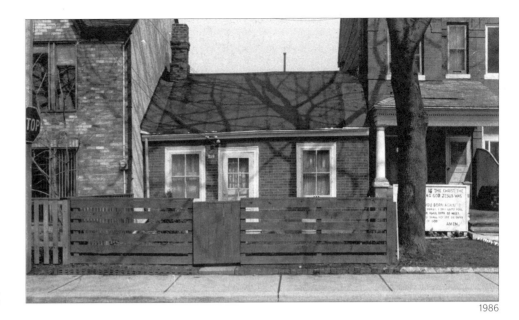

1986

229 Borden Street

We don't see any these days, but bible signs were once seen regularly on Toronto's Presbyterian streets. As for the worthwhileness of 1990s infill projects like this one, maybe we need to wait another few decades before kinder judgements can be made.

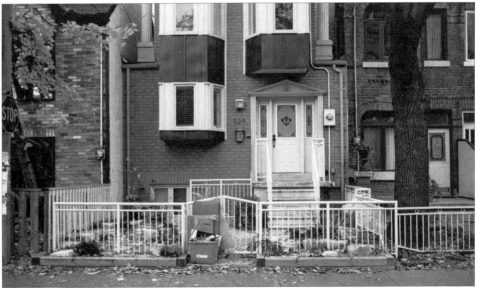

2000

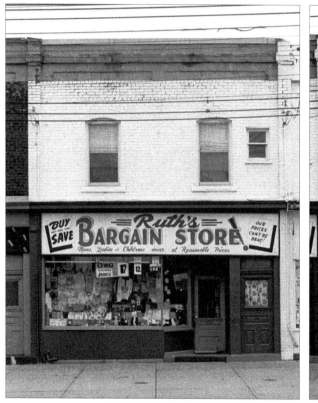
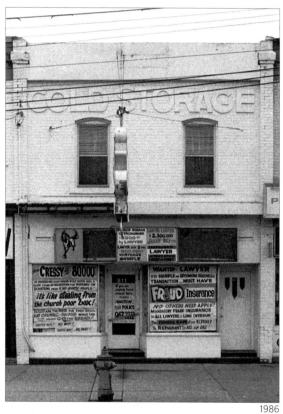

1986

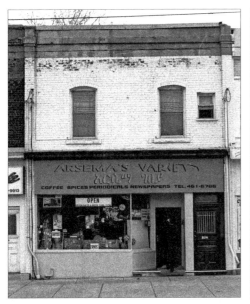
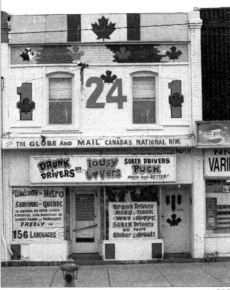

1998

811–813
Gerrard Street East

A once-famous sight on Gerrard Street just past the East Chinatown, one man's battle to preserve the real Canada (and rally against drunk drivers and language laws) is finally over.

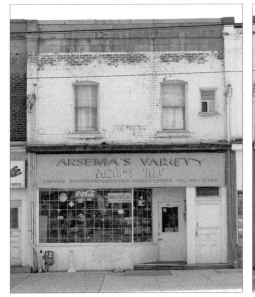
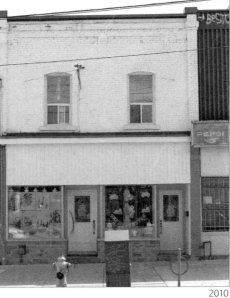

2010

142–156 Argyle Street

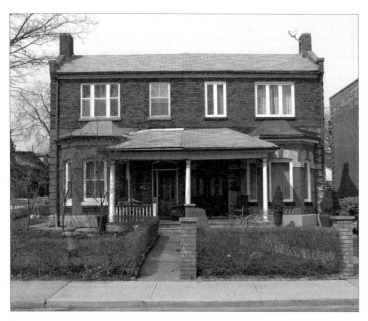 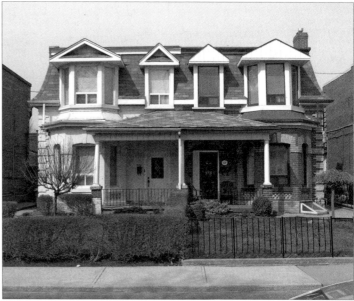

2010

The fate of many of Toronto mansard roofs was to be removed and front walls brought forward for a few more feet of interior space. On the right, a two-storey cottage semi has been converted into a faux bay-and-gable Victorian – a kind of architectural patois.

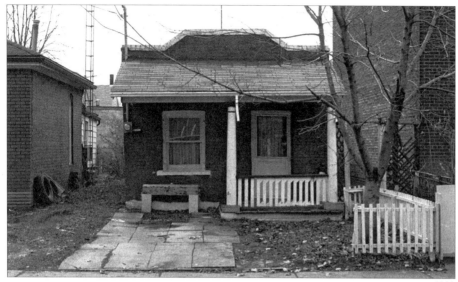

1983

707 Richmond Street West

Tree growth and fence growth (it's all just wood). A pre-cable antenna tower, the kind kids used to get onto rooftops, eventually lies on the ground between houses. A fixer-upper for sure.

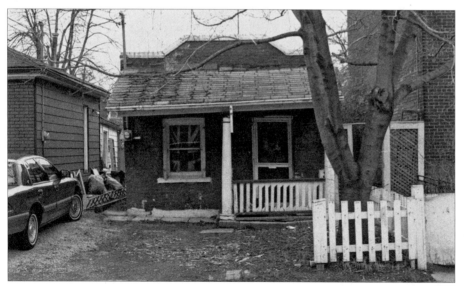

1998

636–642 Gerrard Street East

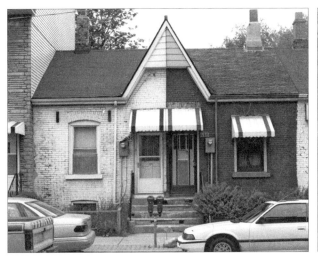
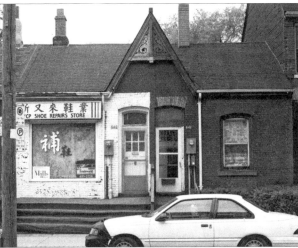

1997

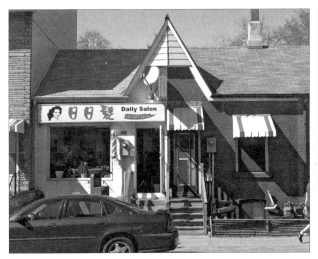
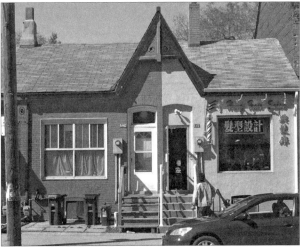

2010

Gothic cottage patterns blender: red and white, businesses and home, interchange and change with the whims of individual entrepreneurs.

1988

1997

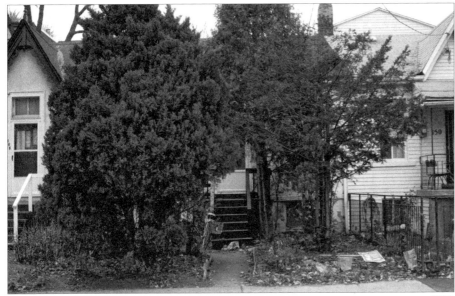

2000

148 Huron Street

A feral house. They fed the fence to the plants and the plants liked it. Those rough picket fences were once found across Toronto. Nothing too ostentatious for Toronto the Good.

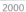

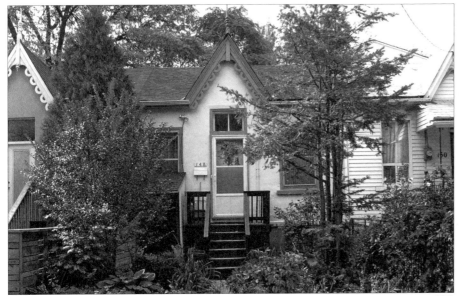

2011

16–34 Brock Avenue

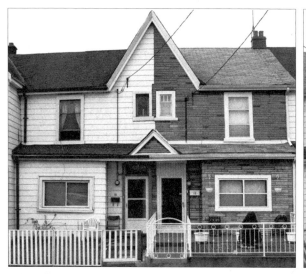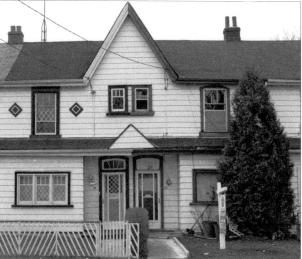

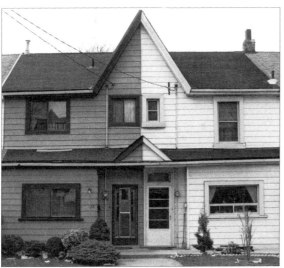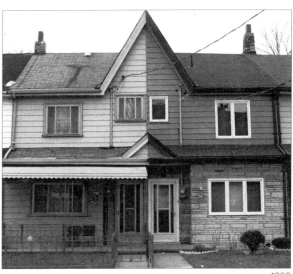

1998

Many rundown Toronto Victorian Gothic buildings like these ones had fallen into disrepair and were renovated in the 1930s under the Standard of Housing By-law 1936 and the Federal Home Improvement Loans Guarantee Act of 1937. Over 9,000 homes were repaired in Toronto by 1939. Later, that renovation was covered with aluminum siding and angel stone. The peaked porches and little middle windows survive from the 1930s improvements.

934–936 Queen Street West

The city we know can change fast: stores, doors, bus shelters and garbage cans. The city is never static.

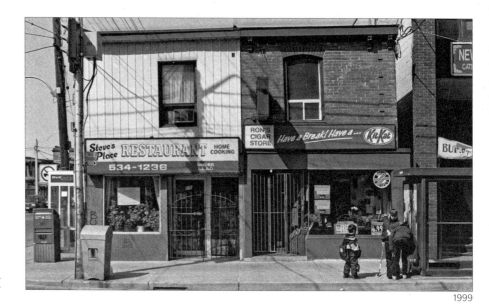

1999

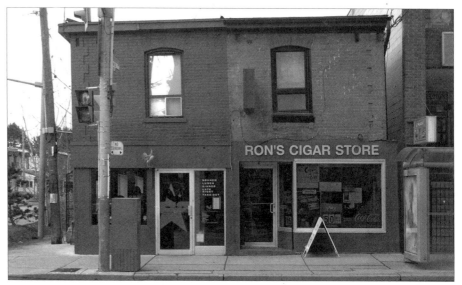

2001

Variety Stores

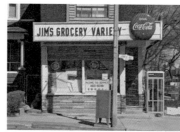
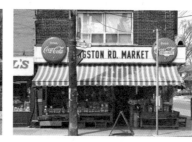
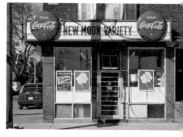
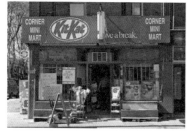
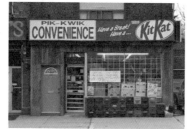
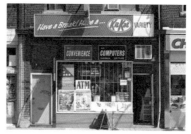
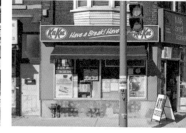
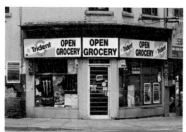
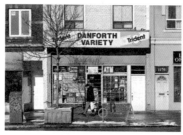
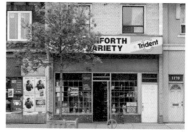
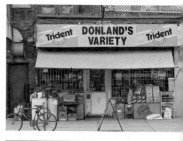
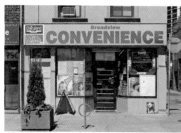
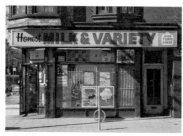
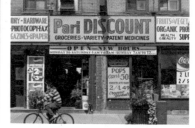
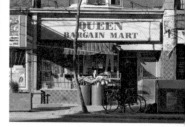
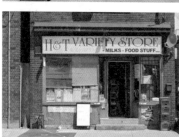
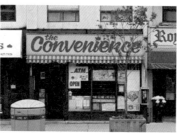
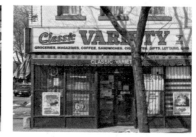
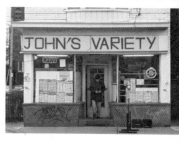

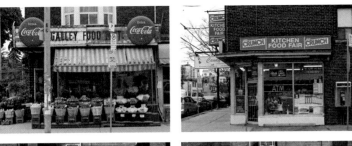
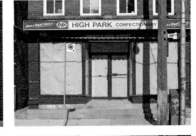
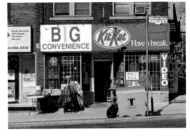
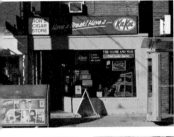
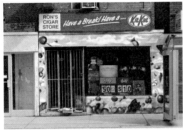
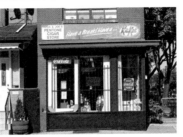
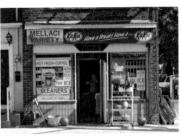
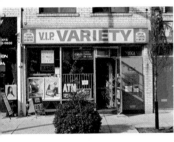
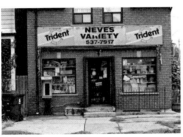
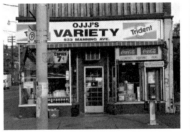
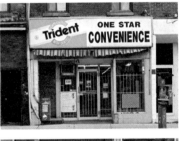
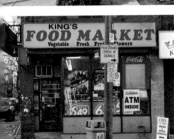
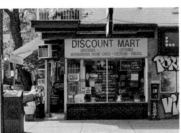
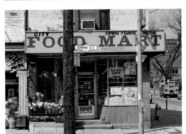
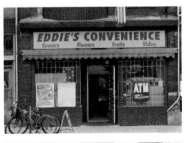
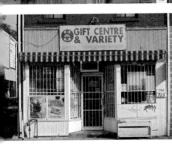
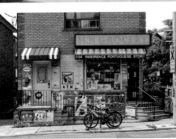
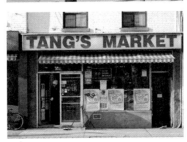
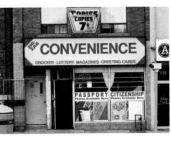

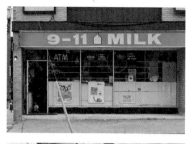
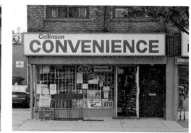
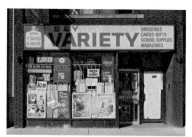
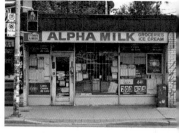
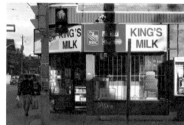
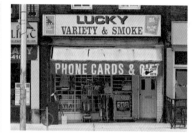
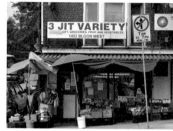
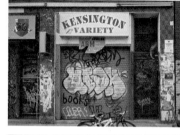
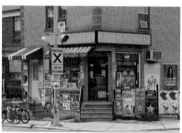
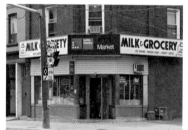
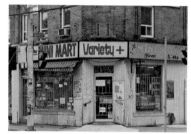
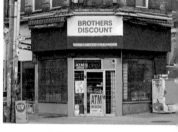
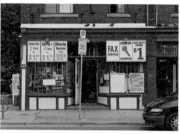
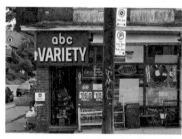
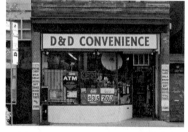

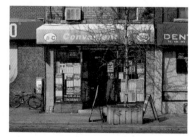
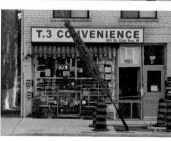

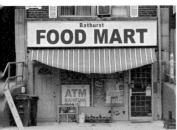
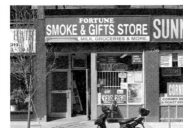
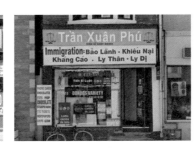
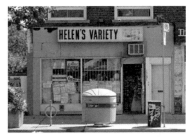
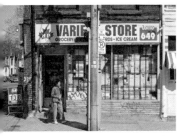
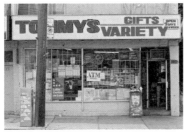
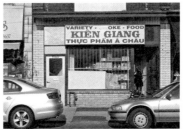
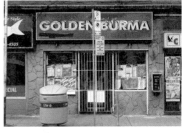
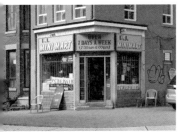
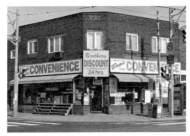
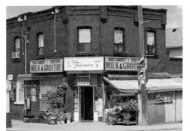
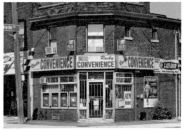
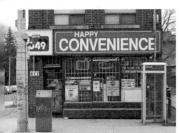
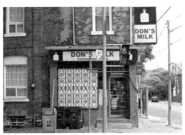
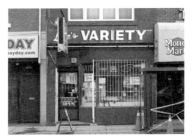
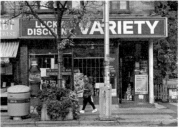
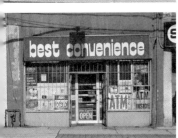
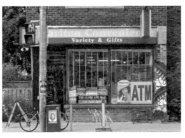
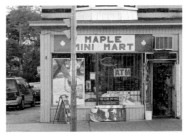
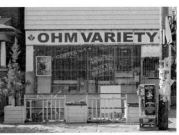

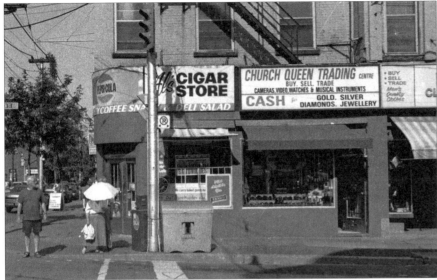

1997

127 Church Street

McDonald's adapted to the city here, not the other way around, as is often the norm. Two stores become one, though; McDonald's can't be expected to get too small.

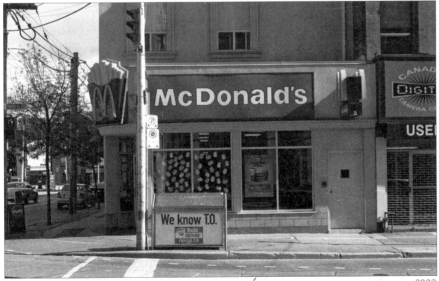

2002

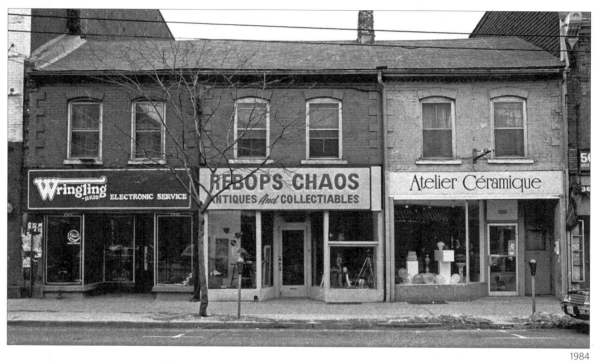

1984

2003

555–559 Queen Street West

Parking meter shift, and style shift. This stretch of Queen has seen fads and fashion cause some of the fastest retail change in the city. Chaos, almost. In the early 2000s, Odyssey was the kind of store that had futuristic dance music–inspired clothing so oddly shaped that I once tried on a jacket and got stuck in it, requiring assistance to have it removed, quickly ending this sartorial flirtation.

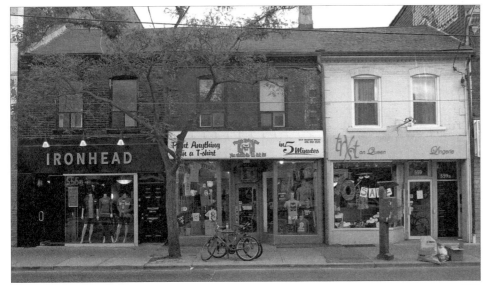

2011

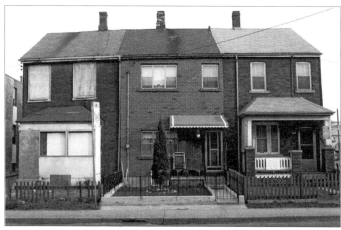

1983

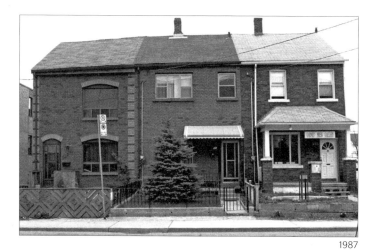

1987

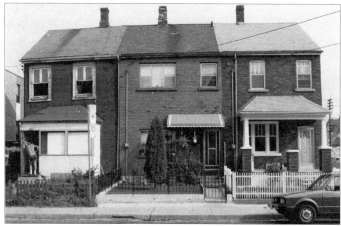

1984

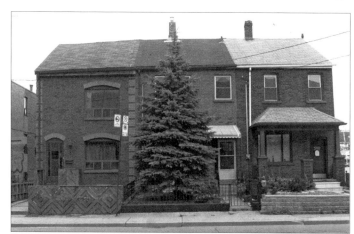

2004

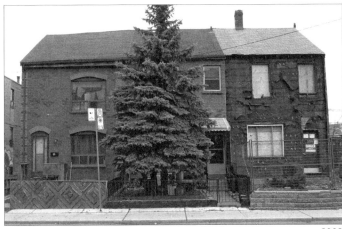

2008

580–586 Richmond Street West

A dump on the left gets a polychromatic brick treatment rehabilitation; Toronto artist Eldon Garnet opens his Garnet Press Gallery, then, probably unrelatedly, the building falls apart, and a spruce tree grows like a condo tower. One block, but a bunch of stories and forces at work.

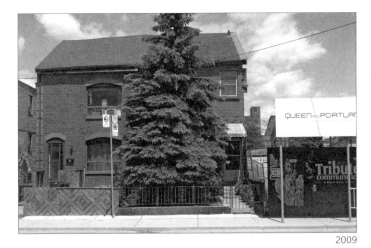

2009

530 Front Street West

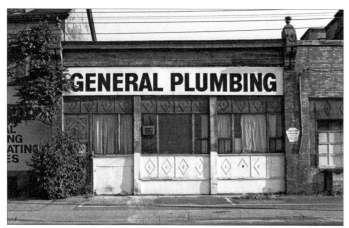

1983

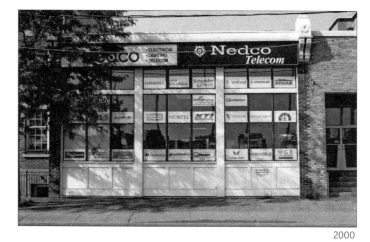

2000

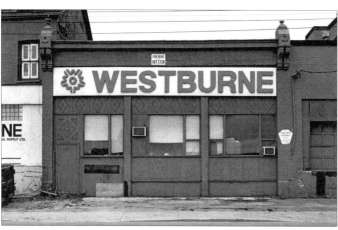

1987

2010

Before General Plumbing this was a produce distribution centre, but through all its iterations it retained its architectural ornament. By grace and luck, not bylaw and preservation activism, bits like these can be found across Toronto.

512 Eastern Avenue

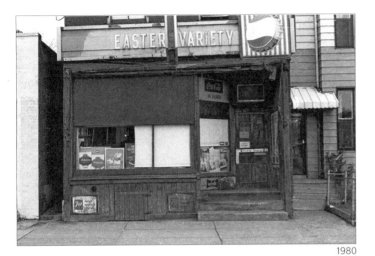

1980

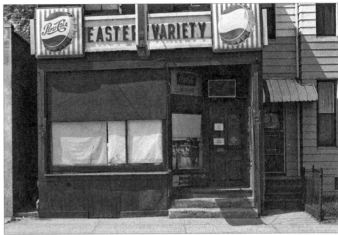

1988

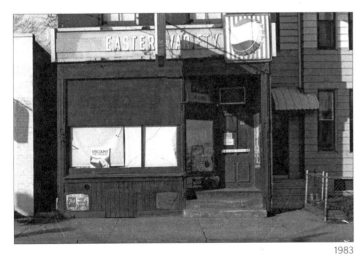

1983

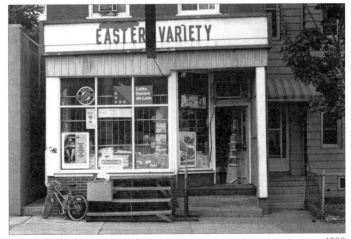

1998

Perpendicular sign placement keeps Eastern Variety in perpetual Easter here at the rough Eastern Avenue edge of the city before the Portlands start. A rare (since Coke dominated the scene) faded Pepsi sign is suddenly joined by another in pristine condition. Found in the basement? Purchased? Then where'd they both go? Ebay? Oh, hello there, tree, where'd you come from so fast?

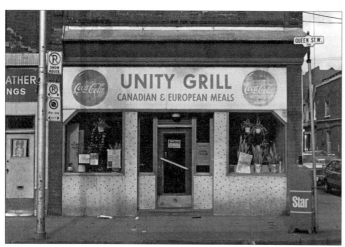

1981

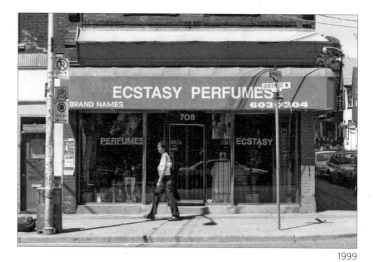

1999

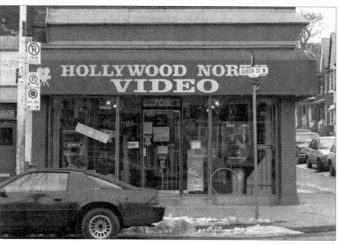

1997

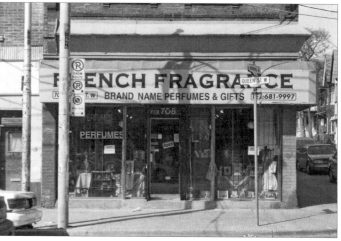

2000

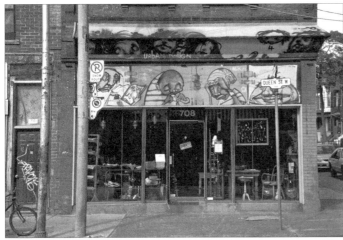

2002

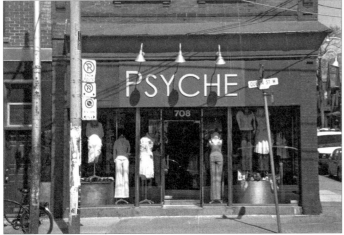

2005

708 Queen Street West

From the old painted-on Coke signs, 708 Queen is a blink-and-you'll-miss-it kind of location. Signage by artist Elicser and a tag by Trik briefly dominated, but disappeared as well.

374 Dundas Street East

Is a store without a sign still a store?

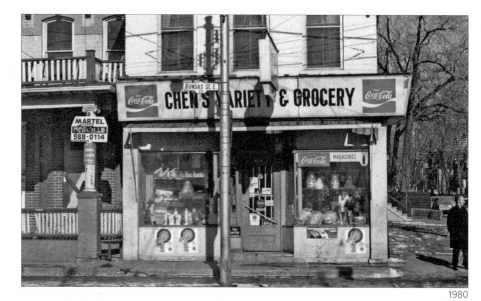

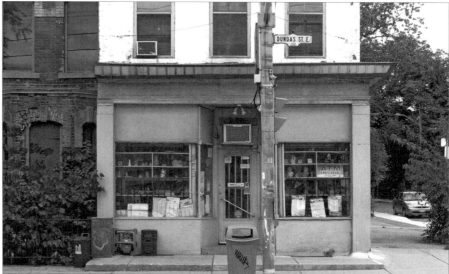

135–139 Christie Street

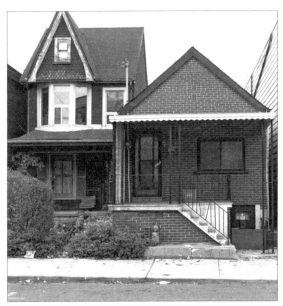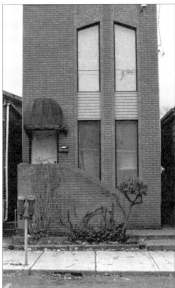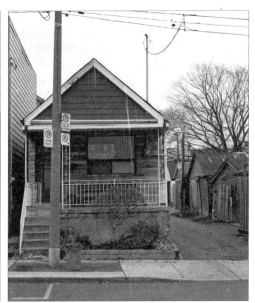

2000

The contemporary fortress house echoes what was likely there before in the shape of the windows; given the lot size, it was likely similar to its DIY neighbours. If I'd lived here in the fortress, I'd have invited people to 'my lair' rather than 'my house.'

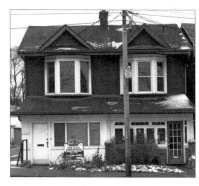
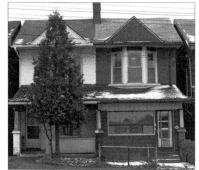
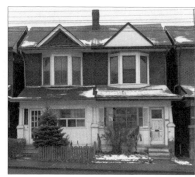

1219–1237
Bathurst
Street

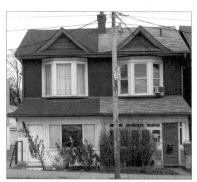
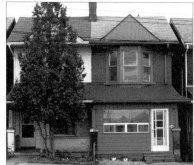
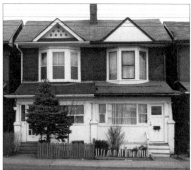

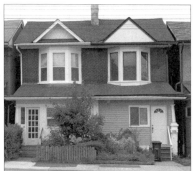

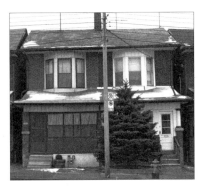 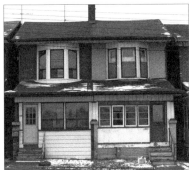 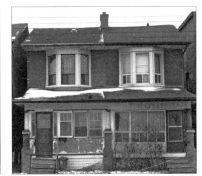

1997

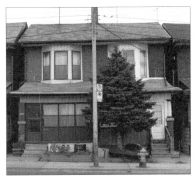 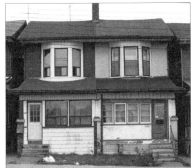 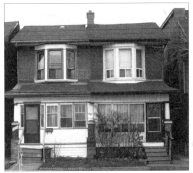

2002

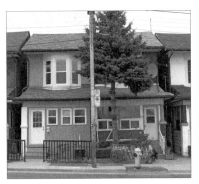 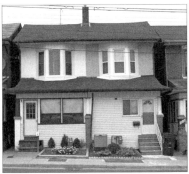 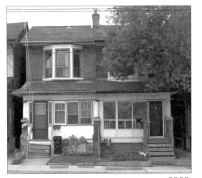

2009

In this fortification of Bathurst, only one home retained the open porch, at least until 2009. In the final row, as across the old City of Toronto, where access to backyards is through narrow passages, if at all, the big black garbage and recycling bins dominate. It's the new plastic Toronto look we have not yet come to love.

1033–1035 College Street

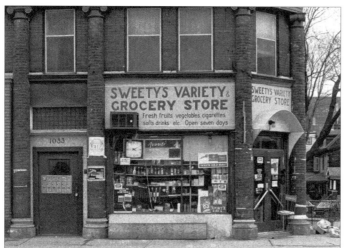

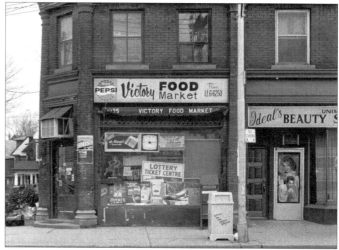

1986

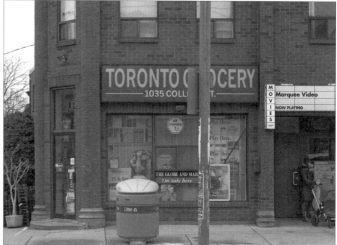

2010

Sometimes we can be kind to our buildings, preserving details, even as these two convenience stores are locked in an eternal retail battle facing each other across Rusholme Park Crescent.

760 Dundas Street West

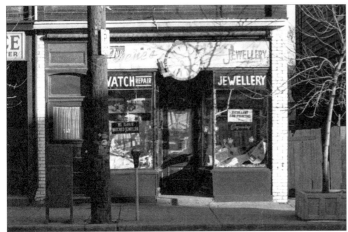

1988

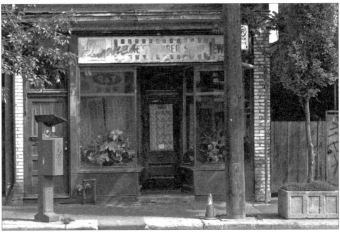

2010

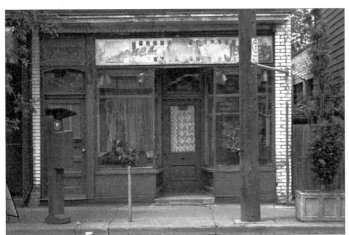

2001

Old logos fade slowly, and old storefronts make good temporary greenhouses until the story of why this Dundas Street shop, perhaps like the Czehoski window widow, is sorted out.

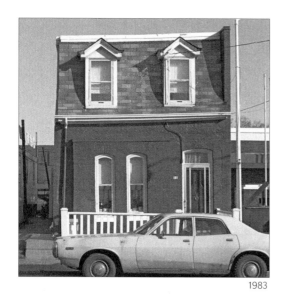

1983

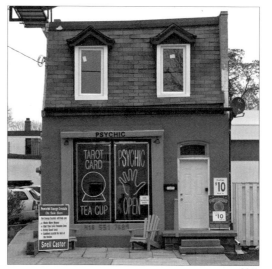

2004

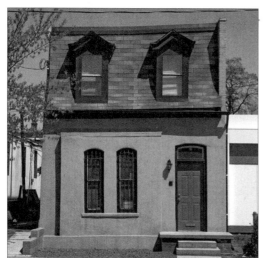

2001

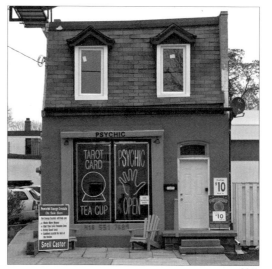

2011

161 Parliament Street

A lonely outpost on Parliament, near the highways that are Adelaide and Richmond, a place where nobody wants to walk or shop, a trend that even a middling psychic should have been able to forecast.

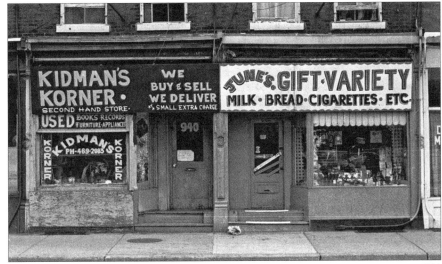

1980

940–942 Queen Street East

Queen East toward the Don River is the oft-forgotten bit of Queen that isn't East Queen, west of Leslieville, moving from hand-painted mom-and-pop to tattoos to, most certainly, soon, a Starbucks, to serve the new condos going in all around.

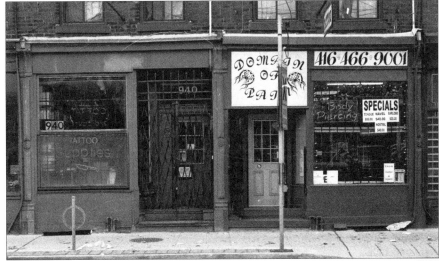

2003

506 Adelaide Street West

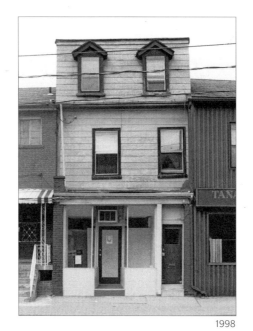

1998

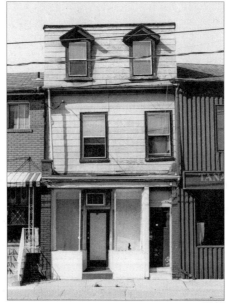

2000

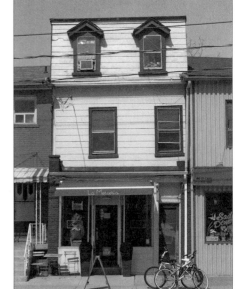

2010

2004

1520 Queen Street West

For a time Studio Brillantine was the only art-and-design-minded store on the Ossington–Drake stretch of Queen, until that hood became the epicentre of everything and SB moved along to Parkdale, here next to a gallery that probably has only one hammer now.

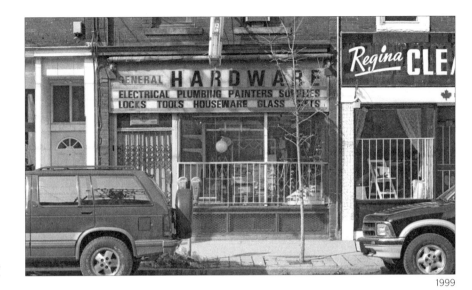

1999

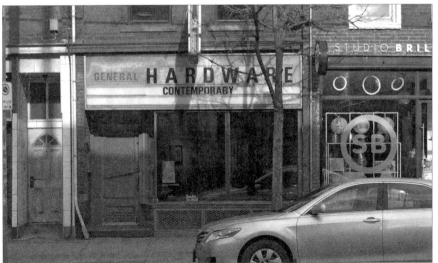

2012

196 Borden Street

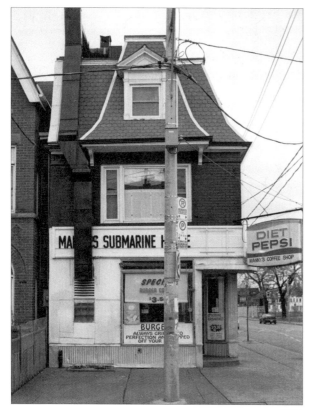

2000

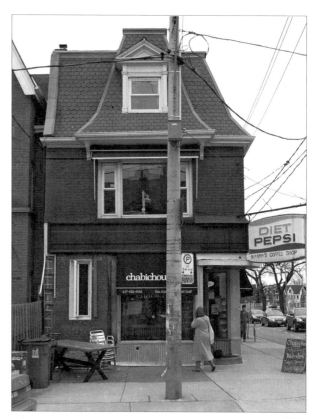

2010

A fine example of a mansard roof with dormer, and the removal of an unfortunately placed exhaust vent.

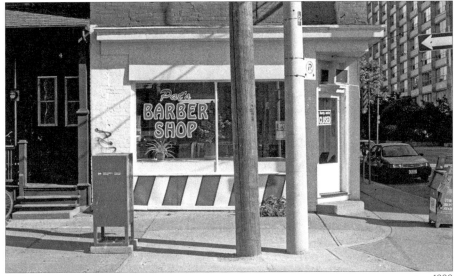

2 D'Arcy Street

Batten down the hatches on McCaul. A perfectly nice building has been clad with EIFS, Exterior Insulation and Finish System, or 'fake stucco.' It's an urban blight, but it's everywhere, a cheap facelift that, like most facelifts, doesn't age well. 'Tag me, please, tag me all over,' it says.

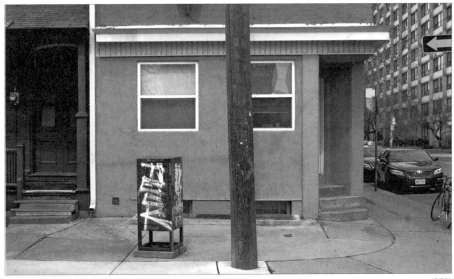

1118–1128 Queen Street West

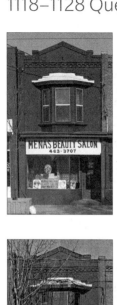 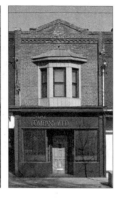 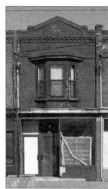 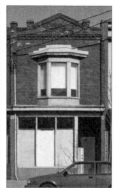 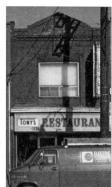 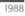

1988

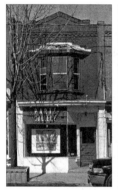 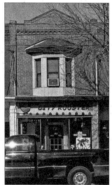 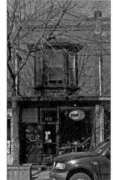 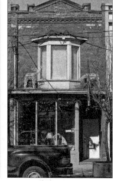 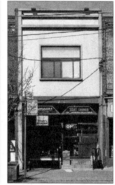 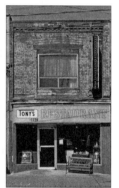

2004

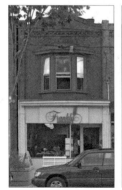 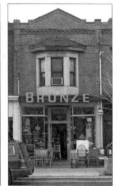 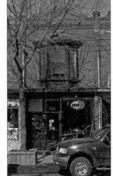 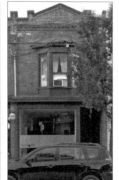 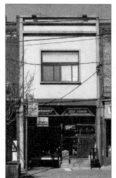 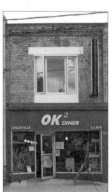

2010

1166–1174 Queen Street West

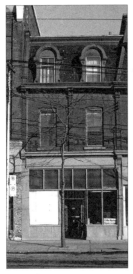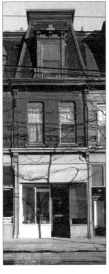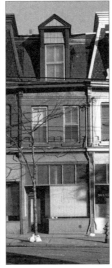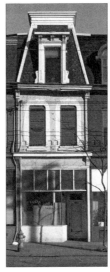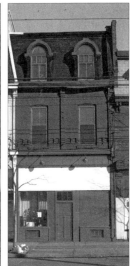

1988

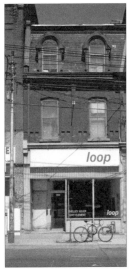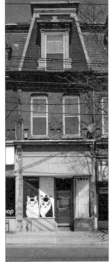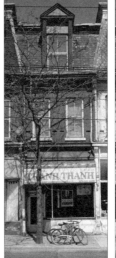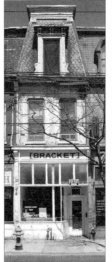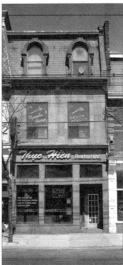

2005

538 Queen Street West

Yes, Virginia, underneath the Bovine Sex Club's twisted metal facade, there is a normal old building.

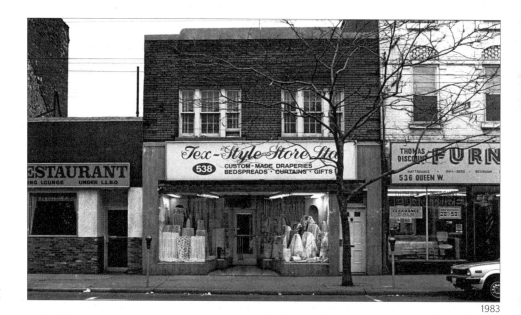

1983

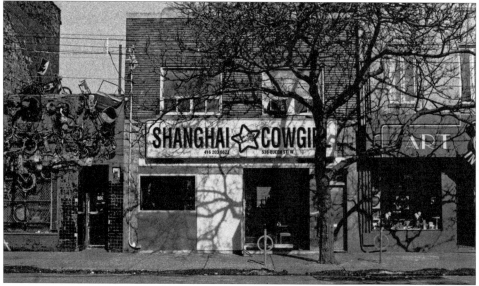

2007

Garages

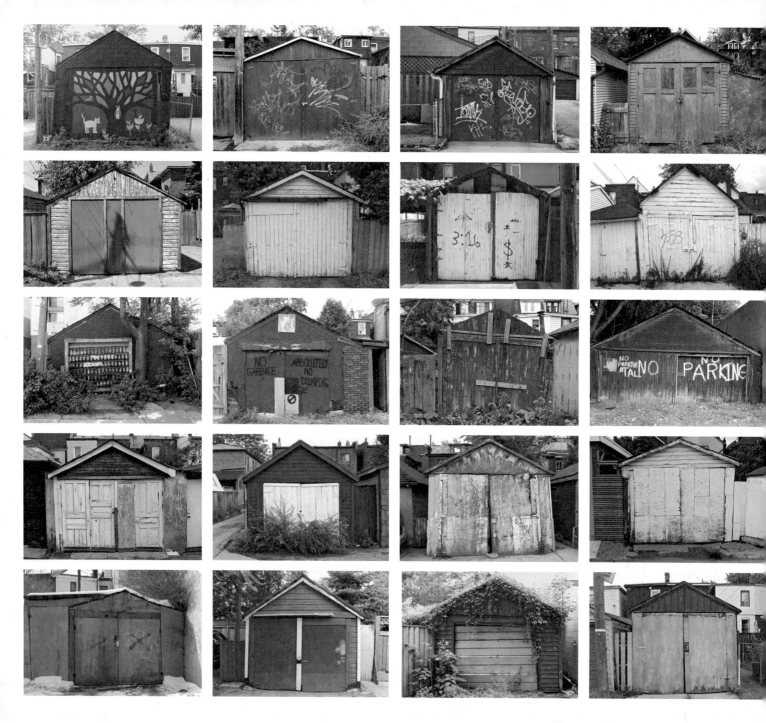

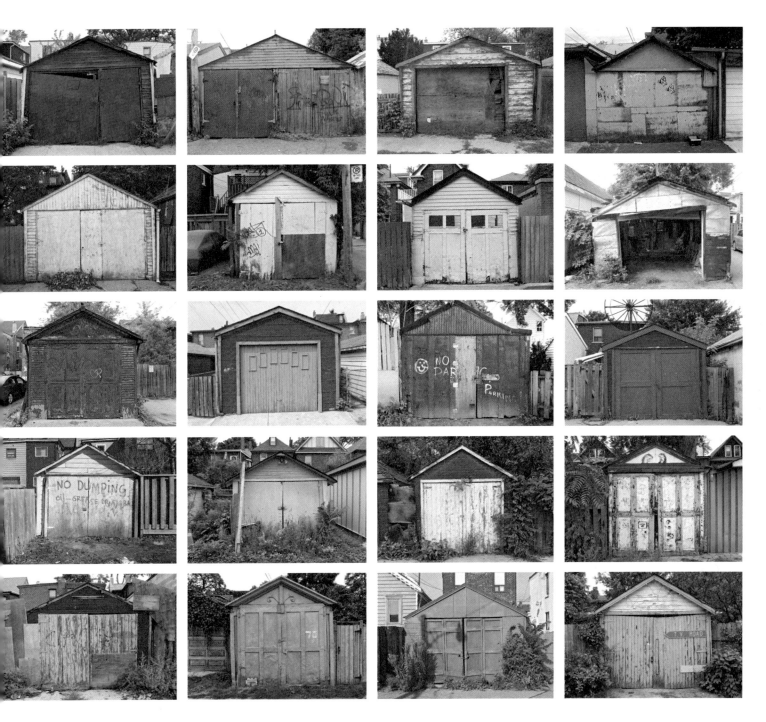

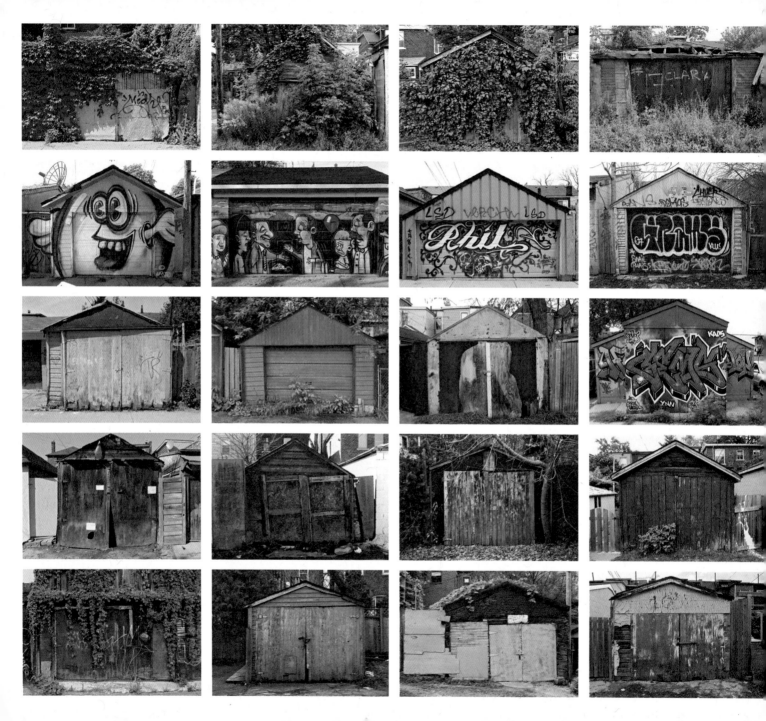

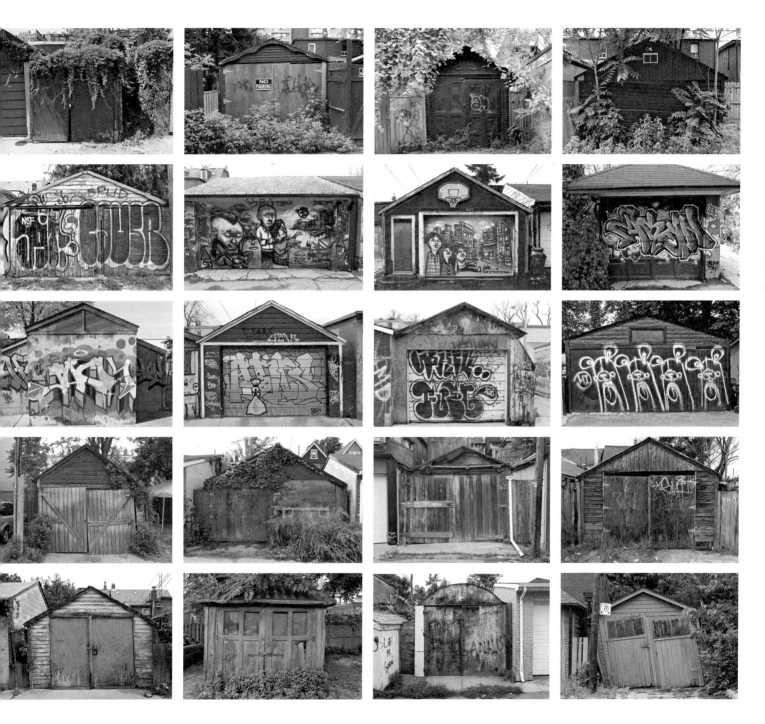

237 Dundas Street East

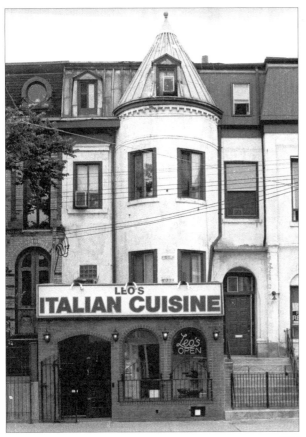

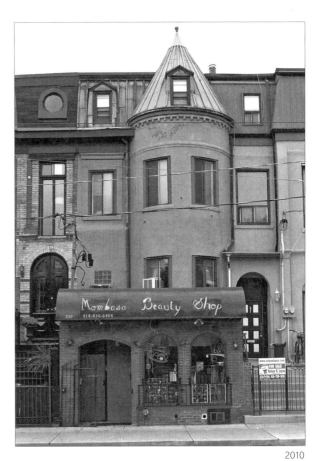

On the Dundas Curve, across from the Filmores strip joint, we have south-of-Bloor castles to match Casa Loma to the north.

123–125 Sherbourne Street

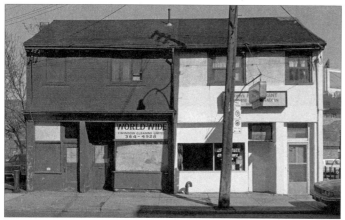

1986

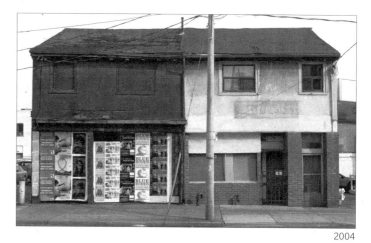

2004

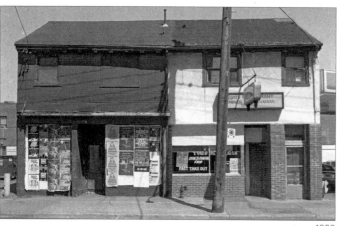

1999

2010

At Queen and Sherbourne, fortification is taken to its most extreme, until one storefront completely disappears. There is condo development all around now, so economic change in the area may yet see a return to retail here.

237–239 Queen Street West

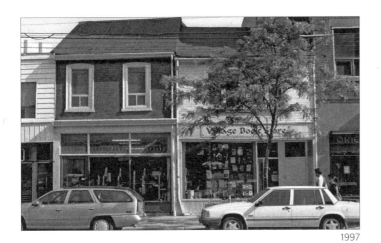

1997

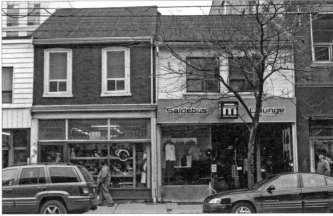

2003

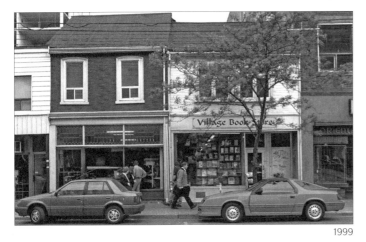

1999

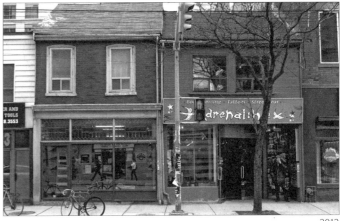

2012

Even the smallest tree can obscure a building when it has leaves.

936 King Street West

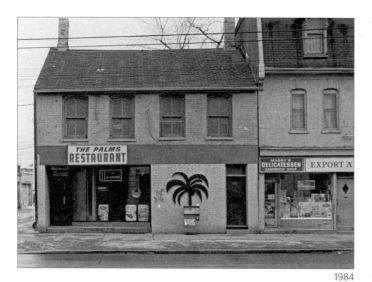

1984

2007

1998

Dude, where's my chimney? It took a while before that spot on the roof was covered up – the details and remnants stick around sometimes. Another one that was never meant to stand the test of time, but did. Also, Toronto needs more palm trees.

2787 Dundas Street West

Something's changed at this location: the sign got olde-timey, perhaps to compete with the 1889 sewer grate, which has remained the same. A discreet garbage becomes something that isn't. A pole moves. In the lower photo, Cummins is visible, a rare glimpse of the photographer, the result of shooting into the light.

2009

135–137 Ossington Avenue

The trunk of that car is big enough to have packed up the Coke button sign and moved on. One store goes dead, and a dead one comes back to life. City roulette.

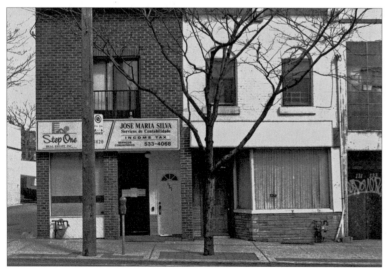

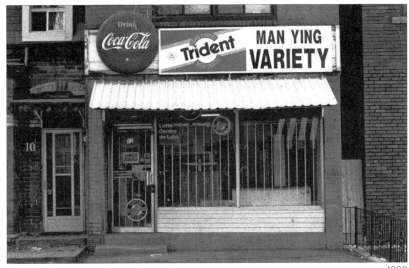

1998

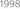

12 Brock Avenue

When Man Ying closed up shop, the previous incarnation was revealed. When things happen fast in the city, layers are added, and there's no time to deal with the past. It's only when things recede that we see those layers unwrap.

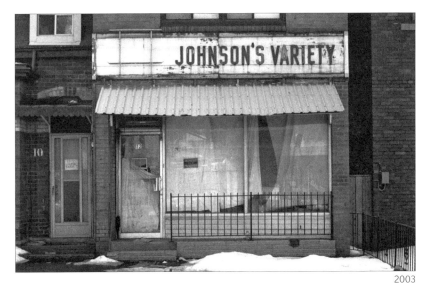

2003

719–721 Richmond Street West

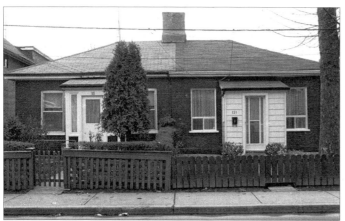

1983

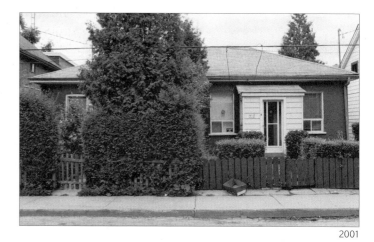

2001

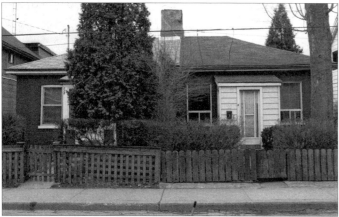

1998

2009

One of the few surviving semi-detached cottages that were built on Garrison Common in the 1850s by James Lukin Robinson, son of author Sir John Beverley Robinson. Probably no one predicted one would go feral, but it was eventually brought under control. An addition was added on the right, and a porch removed, but a curious bit of fence was kept. So much of our city is the way it is because of the whims of individuals

2078 Dundas Street West

Nearby variety goes the distance and becomes Vietnamese, with unintentional OK GIFTS (maybe SMOKE AND GIFTS at one point?). There was a time when you could see out convenience store windows, but now they tend to be plastered over with flyers and ads.

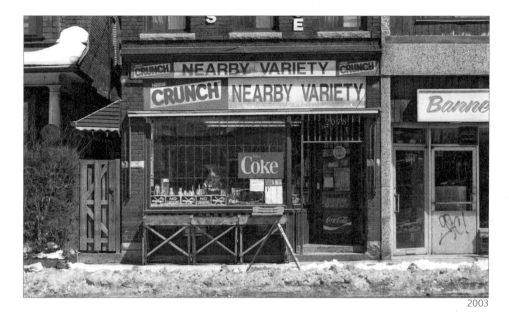

2003

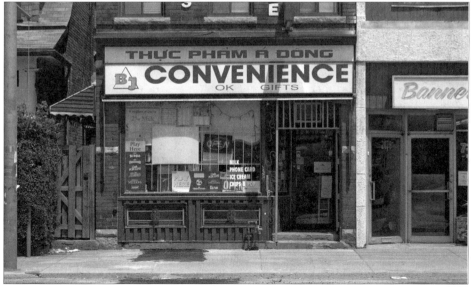

2009

97–115 Gladstone Avenue

 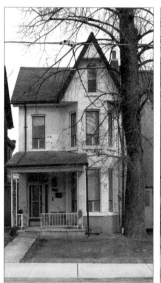 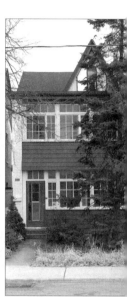

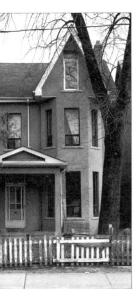 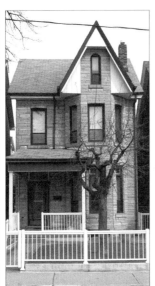 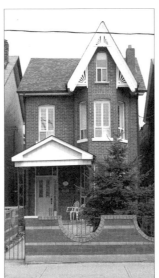 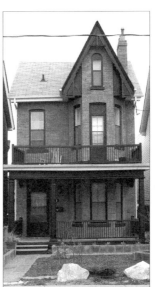 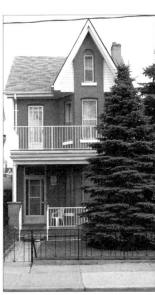

2010

Versatility: a study in all the things you can possibly do to a bay-and-gable Victorian.

173–203 Gladstone Avenue

 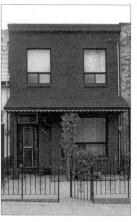 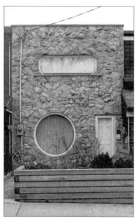 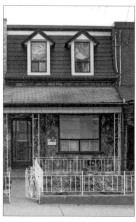 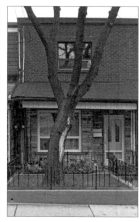

 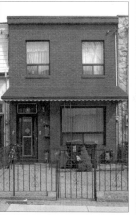 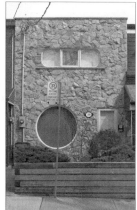 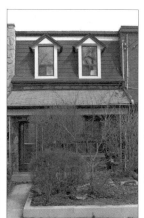 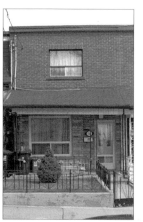

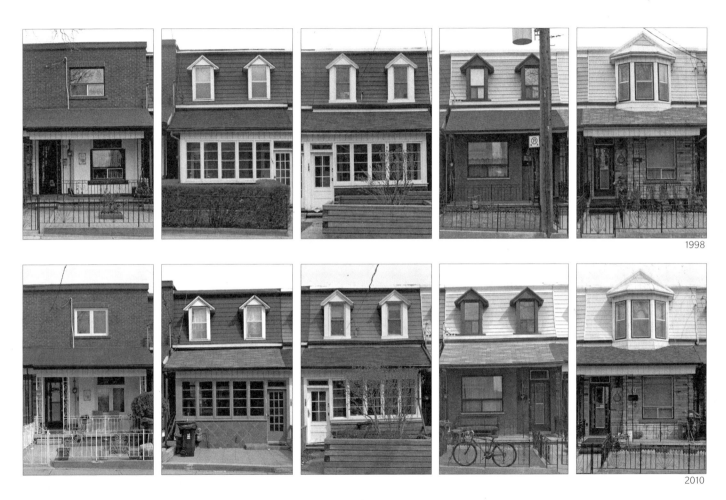

1998

2010

Goodbye, mansard roofs. The psychedelic pill near the left end is the kind of neighbourhood landmark Toronto does well, interior eccentricities brought out on display. This block is very much a study in the history of residential surfacing and fencing in Toronto. Did that scalloped fence on the far right (next page) come later, in response to the round window down the street? It all works in heterogeneous Toronto.

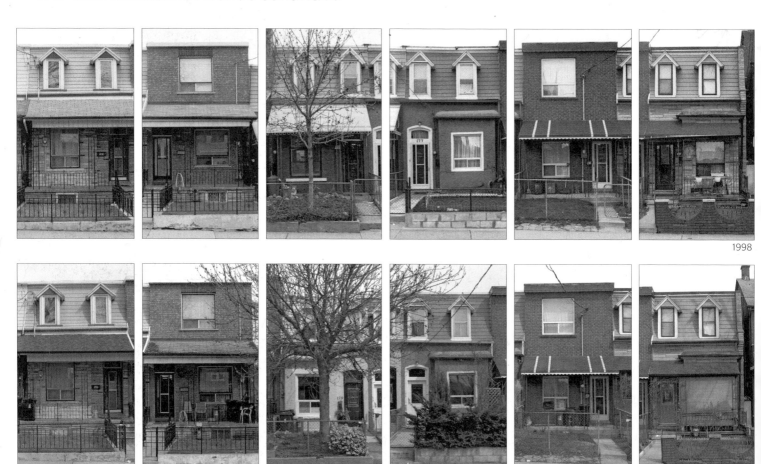

1998

2010

1024 Gerrard Street East

The funny thing with the new is its insecurity; even a minor sign update requires an insistence of provenance.

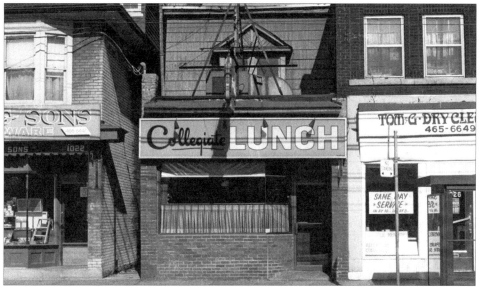

1988

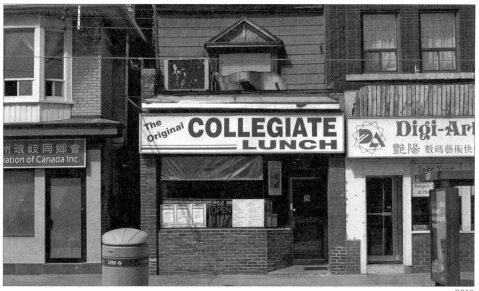

2010

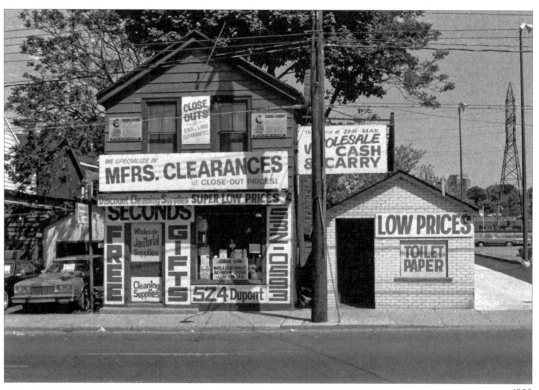

1986

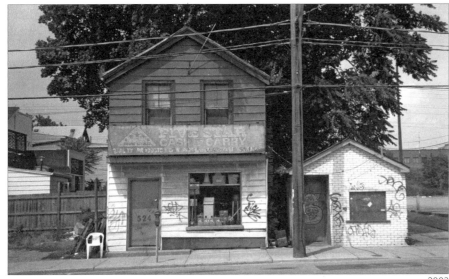

2003

524 Dupont Street

Choose the facade you like best: miniature DIY Honest Ed's, crowd-sourced or the kind of siding that can make a building disappear.

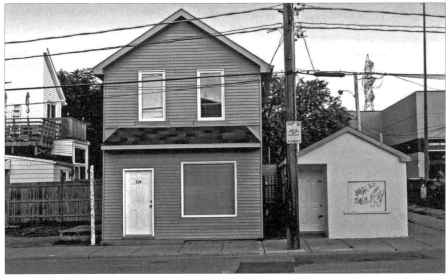

2010

986–998 Queen Street West

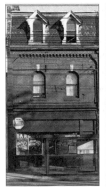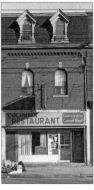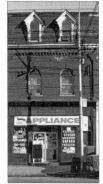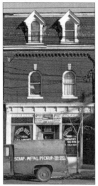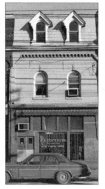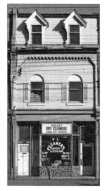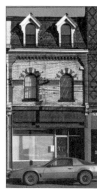

1988

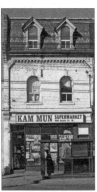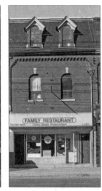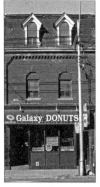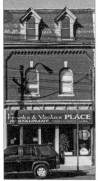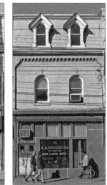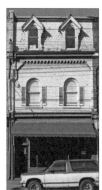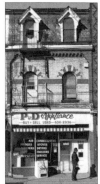

1998

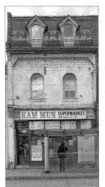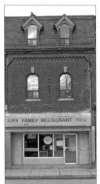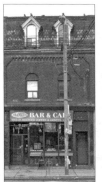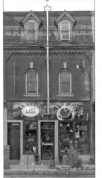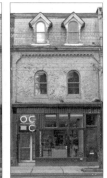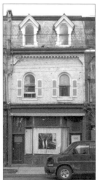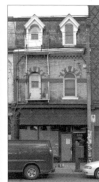

2012

100 Adelaide Street East

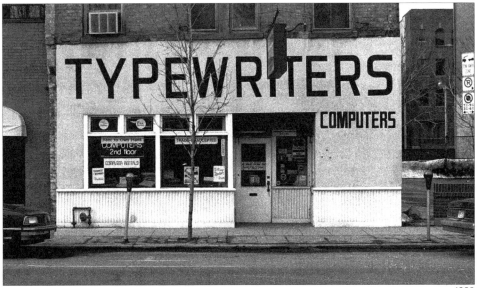

1989

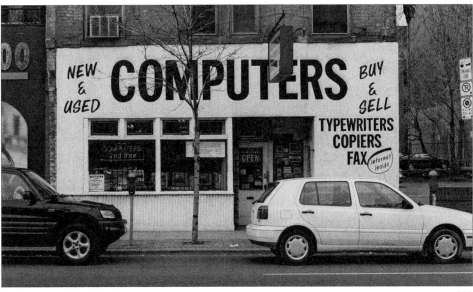

1998

Acknowledgements

Thanks to all those who have shown an interest in my work over the years. Thanks to Coach House for their appreciation of my work and their efforts in realizing it in book form. And thanks to Karen for all of her love and support.

– Patrick Cummins

Patrick Cummins

graduated from the Ontario College of Art (1982), specializing in drawing and photography. He obtained a BA in fine art and philosophy (1983/1984) and an MA in philosophy (1986) from the University of Guelph, writing his thesis on the production and reception of meaning in photography. He has undertaken numerous projects as a photographer exploring the conventions of documentary practice and participated in exhibitions at various galleries (1981 to present). He has photographed aspects of Toronto's built environment since the early 1980s, conducting comparative studies in time and space, documenting the transformation and survival of ordinary residential and commercial structures that constitute the fabric of the city's many neighbourhoods. He is represented in private collections and in the permanent holdings of the Canadian Museum of Contemporary Photography. He has worked in archives since 1986, specializing in photographic, cartographic and architectural records. He has curated four major archival exhibitions and has had his own work featured in the exhibit Building Blocks: Queen Street West 1847–1890 (2007).

Shawn Micallef

is the author of *Stroll: Psychogeographic Walking Tours of Toronto* (Coach House, 2010) and a senior editor and co-owner of the independent, Jane Jacobs Prize–winning magazine *Spacing*. In 2002, while a resident at the Canadian Film Centre's Media Lab, he co-founded [murmur], the location-based mobile phone documentary project. Begun in Toronto's Kensington Market, the project has spread throughout the city and to more than twenty cities globally. He teaches at OCAD University, started the Toronto web magazine *Yonge Street*, and is a 2011–2012 Canadian Journalism Fellow at University of Toronto's Massey College. He writes and talks about cities, culture, buildings, art and politics in books, magazines, newspapers, websites and even in front of real live people.

Typeset in Slate, a typeface designed by Rod McDonald, an award-winning type designer and lettering artist. The Slate family of typefaces blends features of McDonald's earlier sans serifs into a humanistic sans with a great degree of legibility. McDonald drew on the knowledge he gained from a typeface legibility and readability project conducted by the Canadian National Institute for the Blind and his experience creating a sans serif typeface for *Toronto Life* with an exceptionally pure design. McDonald also worked with the Microsoft Typography Team to learn more about ClearType technology, developed to improve the readability of on-screen text. The result is Slate, a beautifully designed typeface that functions as well on the screen as it does on the page.

Printed in April 2012 at the old Coach House on bpNichol Lane in Toronto, Ontario, on FSC-certified Rolland Enviro 100 Satin paper, which was manufactured, acid-free, in Saint-Jérôme, Quebec, from 100 percent post-consumer recycled paper. This book was printed with vegetable-based ink on a 1965 Heidelberg KORD offset litho press. Its pages were folded on a Baumfolder, gathered by hand, bound on a Sulby Auto-Minabinda and trimmed on a Polar single-knife cutter.

Edited and designed by Alana Wilcox, with help from Rick/Simon and Evan Munday

Coach House Books
80 bpNichol Lane
Toronto ON M5S 3J4
Canada

416 979 2217
800 367 6360

mail@chbooks.com
www.chbooks.com